P9-BJR-457

THE
INNER EYE
OF ALFRED STIEGLITZ

Robert E. Haines

UNIVERSITY
PRESS OF
AMERICA

Copyright © 1982 by

University Press of America, Inc.

P.O. Box 19101, Washington, D.C. 20036

Library of Congress Cataloging in Publication Data

Haines, Robert E.
 The inner eye of Alfred Stieglitz.

 Bibliography: p.
 1. Stieglitz, Alfred, 1864-1946--Influence.
I. Title.
TR140.S7H34 1982 770'.92'4 82-13641
ISBN 0-8191-2717-5
ISBN 0-8191-2718-3 (pbk.)

TO KATHARINE DE'NEIL

Va para ti.

.

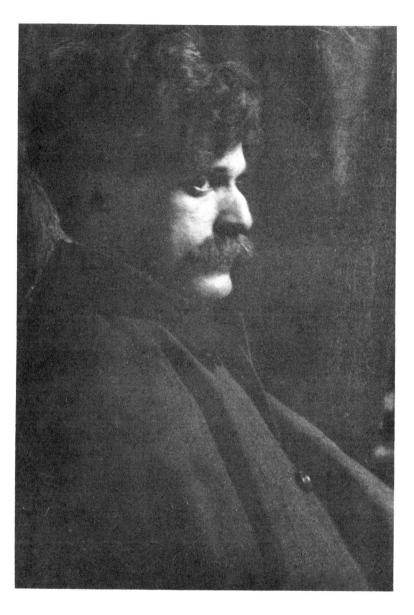

Alfred Stieglitz in 1900 by Frank Eugene

ACKNOWLEDGMENTS

For the help they gave me at various times and in divers ways, I would like to thank Ansel Adams; Doris Bry; Peter C. Bunnell; Angus Cameron; Hilbert H. Campbell; Bram Dijkstra; Joseph G. Drazan; Donald Gallup; Millicent B. Hering; George Knox; Charles E. Modlin; Walter J. Mueller; Beaumont Newhall; the late Nancy Newhall; Amy Nyholm; Walter B. Rideout; William L. Rivers; the late Claude M. Simpson, Jr.; Roger B. Stein; Neda M. Westlake; and Anne Whelpley.

For their cooperation and understanding, my special thanks to Mrs. Sherwood Anderson; Mrs. Waldo Frank; Dorothy Norman; Georgia O'Keeffe; and Herbert J. Seligmann.

I am also indebted to the National Endowment for the Humanities for the summer stipend that in part supported the writing of this book.

viii

CONTENTS

INTRODUCTION

Stieglitz was anything but a conventional person, and he would have been the last to alter anyone's creative trajectory. Thus the reader should not presume that the following pages are a traditional study of literary or artistic influence. There were instances, it is true, when his work or his very presence impinged on those around him, but the Stieglitzian impulse was always to move in the direction dictated by your deepest inclinations. Stieglitz's consistent message to the world was to follow your innermost urge, for only then will you achieve your best, your truest work. Georgia O'Keeffe told me that her husband inspired, even goaded, everyone to do the best work he could, no matter what field of endeavor the person chose. This, then, was the true universality of Stieglitz.

In Stieglitz's world there were no schools of art. Each artist must, above all, be himself. If that self, as reflected in the artist's "premises" happened to be uncongenial, Stieglitz was not dismayed. But he insisted that all art be "alive," that it contain some measure of the vital essence of universal life. The same criterion held true for all human effort, for everything is embedded in an organic cosmos.

Only rarely did Stieglitz's influence result in a visible alteration in an artist's subject matter or his style. One might expect a younger, admiring photographer to have been influenced by Stieglitz in a specific, tangible manner. But consider Ansel Adams' recollection: "Stieglitz had an impressive effect upon me. But I have never been able to pin down just what it was. Semantics fail and magic cannot be defined. . . . The man himself was a presence, defining the undefinable, revealing hidden dreams and mysterious perceptions. He could be precise, contradictory, mind-bending, exasperating, and loveable. I owe Stieglitz a tremendous debt. Perhaps he did more than anyone to bolster confidence in my most personal perceptions and aspirations."[1]

This tribute adumbrates the effect that Stieglitz had on those who gravitated to him, whether they were painters, photographers, or writers: he stimulated and

encouraged his friends to realize their own unique potentials--even if, as sometimes happened, the products were baffling or distasteful to Stieglitz himself. In his ceaseless crusade to actualize the human spirit, he reminds one of the great social and religious leaders of history. And his insistence on art for life's sake qualifies him as one of the eminent humanists of his time.

Some readers may expect this study to be a comprehensive treatment of Stieglitz's photography as photography.[2] But I have deliberately avoided such a concentration because I agree with Hutchins Hapgood that "what makes [Stieglitz's] peculiar value is not his photographs, innovating and remarkable as they are, but his restless life-breathing personality, his endless quest."[3] Never did Stieglitz allow the art object per se to dominate the vital impulse, and it would dishonor his message to do so now. The pathway to understanding the inner eye of Alfred Stieglitz lies not in endless commentaries on the products of that vision. We must, instead, seek a total grasp of his "mechanism"--the interlocking structure of his life and concepts. This study is a prolegomenon to Stieglitz's metaphysics.

Those who were most touched by Stieglitz regarded themselves not as followers but as fellow pilgrims, tracing convergent paths to a common end. Like their prime mover, they were impelled by a "restless desire to live and make live." Sometimes the demands of leadership required Stieglitz to assume a paternalistic manner. Sherwood Anderson looked upon him as "more than father to so many puzzled, wistful children of the arts." But those who rallied to Stieglitz's call for idealism in life and in art were fiercely independent beings, and uniting them into something resembling a group was in itself a notable achievement. Yet the Stieglitzians were never servile. "I think I felt Stieglitz's work so intensely," Hutchins Hapgood commented, "because I myself was working in the same direction in another field."[4] Hart Crane said almost exactly the same thing. Synchronous effort, calibrated by Stieglitz's extraordinary vision, was the very pattern of his myriad relationships, as we shall now see in more detail.

NOTES

INTRODUCTION

[1] Ansel Adams, "My 50 Years in Photography," Popular Photography, August 1973, p. 142.

[2] The definitive treatment of Stieglitz's photography is Dorothy Norman, Alfred Stieglitz: An American Seer (New York: Random House, 1973). For a thorough description of his impact on the American art world, see William Innes Homer, Alfred Stieglitz and the American Avant-Garde (Boston: Little, Brown, 1977).

[3] Hutchins Hapgood, A Victorian in the Modern World (1939; rpt. Seattle: Univ. of Washington Press, 1972), p. 337.

[4] Hapgood, p. 339.

CHAPTER 1

THE NEW CONSCIOUSNESS

Stieglitz as Catalyst

That "one man in his time plays many parts" was a truism even on Shakespeare's stage, and, by the same token, Stieglitz's career is impossible to formulate in a phrase. His daughter once complained that, unlike her schoolmates, she could not pin down her father's occupation. Stieglitz replied: "I'm a little over fifty years old and if anyone ever asks you again what your father is . . . say that I told you that I'd spent all my life trying to find out who and what I am."[1] Stieglitz explicitly refused to call himself a photographer and said that if anyone ever called him an artist, he would kill that person on the spot.[2] He was certain only that he was "one of the leading spiritual forces in this country."[3] Thus his career, like that of his friend Theodore Dreiser, was a never-ending search for a theory of existence.

Of the myriad roles assumed by Stieglitz during the half-century that he was active, probably the most consequential and certainly the most prevalent was that of catalyst. This function was underscored by a devoted observer of Stieglitz's later career, Herbert J. Seligmann: "Not the least of his amazing powers was the ability to release people so that sheer and often unconscious impulse on their part took form in word."[4] And again, "He had the faculty of not merely gazing at, but into, people; and so also the power of releasing in those with whom he talked, elements in themselves of which they were hardly, if at all, aware."[5] Even Gorham Munson, while denying that Stieglitz was a prophet or a teacher (because he had no message), confirmed this stimulus, saying that the purpose of Stieglitz's "monopolizing talk [was] to awaken the listener and impel him to experience."[6]

There are those, myself among them, who would say that such dynamism is a particularly effective kind of teaching; but pedagogy lies outside the province of the present study. The questions at issue are, what was the nature of Stieglitz's impact on American letters,

and how far did it extend?

Consider, as a first step toward an answer, the catalytic effect that Stieglitz had on Sherwood Anderson. The middle-aged Ohioan's decision to forsake retail merchandising for writing was the result of pressure that had built up in him for years, and the whole episode has been hopelessly clouded by the author's imaginative refraction of it in A Story Teller's Story, in his Memoirs, and especially in his essay "Why I Left Business for Literature."[7] Despite the obfuscation, a crucial factor in the decision, one which Anderson chose not to remember in his parables and one which biographers have persistently overlooked, was the "kind of revolution" that Anderson went through during his 1919 visit to New York. "Several things happened," Anderson reported to Waldo Frank, his sponsor among the Eastern intelligentsia and a direct pipeline of Stieglitzian values, "I saw the O'Keeffe things and the Stieglitz things. I went into a gallery [Durand-Ruel?] and saw some paintings by Renoir. I found out the old lesson that one cannot muddy oneself and be clean." An apparent conclusion followed without pause or qualification: "I shall have to get out of business at once, within a month perhaps."[8]

That Anderson was unable to free himself from the Long-Critchfield advertising agency does not diminish the epiphany he experienced three years earlier. He had seen immaculate examples of art untainted by the rampant commercialism that both he and Stieglitz recognized as a cancer on American life, and thus we must credit Stieglitz's photographs as supplying part of the impetus that finally propelled Anderson out of the world of business and into that of art.

Since 291, Stieglitz's famous gallery at 291 Fifth Avenue, had closed in 1917, Anderson must have seen the Stieglitz and the O'Keeffe "things" either in the room that the photographer continued to maintain for at least two years after 291 died[9] or at his brother's house on East 65th Street.[10] In either case, Anderson undoubtedly was taken there by Waldo Frank, who was the first of the Eastern critics to discover the author of Winesburg, Ohio, and who, at the time of Anderson's visit, was profoundly under the influence of cher maître Stieglitz.

That same year saw the publication of Frank's Our America, a virtual handbook to Stieglitz. Since Stieglitz was almost always present in his galleries, Anderson likely met the master himself when he saw his prints, but later he said that it was not until 1922 that he came "to know and really value" the photographer."[11]

No doubt what Anderson first saw and responded to in the work of Stieglitz and O'Keeffe was the same lyrical expression of felt experience that he himself had employed in the recently published Winesburg tales, a lyricism he would continue to exercise, with erratic success, throughout the remainder of his career. Here, moreover, he perceived two artists who had miraculously found a way to survive by sealing off, ironically in a Fifth Avenue office building, a tiny pocket of atmosphere as yet unpolluted by the leviathan of business and the greed for gold.

The initial impact of Stieglitz and O'Keeffe on Anderson is clear enough, but what Renoir meant to him remains conjectural. Perhaps like his contemporary Walter Pach, Anderson welcomed "that unquenchable youth of [Renoir's] ancient country, always thrilling to the beauty of young faces and bodies and flowers of which poets and artists have been singing ever since they had voices at all."[12] At any rate, Anderson must have regarded Renoir's joyous celebrations of the flesh as the very antithesis of the decadent puritanism which he saw strangling the artistic and intellectual life of America and which, in the form of persistent outcries against the "nastiness" of his stories, plagued him from the publication of "Hands" in 1916 to the end of his life. The three--Stieglitz, O'Keeffe, and Renoir-- prefigured for Anderson the emotional fulfillment he had vainly sought in business and now seemed on the point of finding in art.

A few years later, Stieglitz's catalytic effect on Anderson took a specific and concrete form. Having decided to write an article about Stieglitz's mysteriously invigorating presence, Anderson searched in vain for a lead or keynote. He found it finally in a letter from Stieglitz dated September 22, 1922. "Your letter did something," he told the photographer; "a sentence

of yours awoke an old chord--just the thing I wanted to say at the beginning." The crucial letter has vanished now, but Paul Rosenfeld explained that it was the phrase "your old Stieglitz" that triggered Anderson's essay. The piece began, "old man--perpetually young-- we salute you," and went on to develop one of Anderson's favorite themes, "that old male love of work well done."[13] The storyteller had discovered in Stieglitz the perfect exemplar of this theme.

The part it played in Anderson's "revolution" is only one instance of the galvanic effect that Stieglitz had on American writers' consciousness. A more vivid example occurred when young Hart Crane discovered Stieglitz's prints. After Crane moved to New York in 1923 (like Anderson, fresh from the hinterland), it was almost inevitable that he would soon find himself face to face with Stieglitz, for Crane's host and early mentor, Gorham Munson, frequently visited the 291 gallery and had for some time been accepted as a member of the Stieglitz circle. (This was before Munson cast down Stieglitz for Paul Elmer More.) Indeed, shortly after Crane moved into Munson's apartment, the two friends made a trip to the Anderson Galleries at Park Avenue and 59th Street to view the current exhibition of Stieglitz's prints. For Crane the pilgrimage included an experience of almost mystical intensity. Years later the incident was still fresh in Stieglitz's mind, and he was able to recall it in detail for Brom Weber, who in turn related:

> Crane walked into the gallery, where
> a number of Stieglitz photographs
> hung on the wall. Suddenly he
> remained quiet before a print. . . .
> Seeing Crane standing motionless
> before the print, Stieglitz came up
> to see what he was examining so
> intently. As he did so, Crane
> turned, and with the enthusiasm
> characteristic of him when making
> an artistic "discovery," declared:
>
> "That is it. You've captured
> life."[14]

The print that so transfixed Crane, <u>Apples and Gable, Lake George</u> (1922), shows rain-drenched apples, ponderous and explosive with fulfillment, poised before the up-thrusting gable of Stieglitz's summer retreat, the massive weight of the fruit (presented close up) in precise tensile balance with the sky-cleaving back-drop.[15] This "moment before Apples & Gable," reverently recalled again and again in letters exchanged by the two men, sparked an instant resolve on Crane's part to write the definitive analysis of Stieglitz's achievement, a decision that Stieglitz himself encouraged by telling the poet that his initial "conjectures" were the "only absolutely correct statement that [Stieglitz] had thus far heard concerning [his] photographs."[16]

Crane dashed off three paragraphs and a quotation from Blake, and posted the fragment to Stieglitz for his approval. But there the work ended, for Crane, impetuous as always, began the essay with what should have been its climax, and consequently found that he had nowhere to go without repeating himelf. The incomplete essay is valuable, nonetheless, because it contains the kernel of Crane's reponse to Stieglitz, and because it amplifies what the poet meant by truth when, by way of a preface to the essay, he told Stieglitz, "That moment [in the gallery] was a tremendous one in my life because I was able to share all the truth toward which I am working in my own medium, poetry, with another man who had manifestly taken many steps in the same direction in his work."[17]

Crane's essay makes it clear that Stieglitz's success in making truth visible is a complex process. The first step involves the camera's ability to arrest motion so precisely that it eternalizes the moment and conquers life's fleetingness. For whatever reason, Crane does not mention the obvious parallel here to Keats's "Ode on a Grecian Urn" but instead hails the camera as a device capable of capturing the mystical fourth dimension of P. D. Ouspensky.[18] Thus the machine becomes for Crane a tool of metaphysics.

Movement being the most evident sign of life, Crane goes on to say that this containment of speed ("the moment made eternal") reveals the living sentience, the "motion and emotion," of seemingly inanimate objects,

thereby reflecting the "ultimate harmonies" of spirit and matter. In the end, says Crane, Stieglitz's photographs draw the viewer toward the very essence of things in the same way that Blake's "golden string" leads to ultimate reality through "Heaven's gate, / Built in Jerusalem's wall."[19]

Piercing the wall between human finitude and essential reality, then, was the truth toward which both Crane and Stieglitz were striving, but of course the recognition of spiritual reality versus physical appearance originated with neither of these men. The central dualism of Western thought goes back at least as far as Plato, and the work of Crane and Stieglitz signaled a twentieth-century revival of philosophic idealism. In the vanguard of the new idealists was Henri Bergson, and he reminded artists that their special task was "to brush aside the utilitarian symbols, the conventional and socially accepted generalities, in short everything that veils reality from us, in order to bring us face to face with reality itself." This injunction is part of a long excerpt from Bergson's Laughter (1900) that Stieglitz's Camera Work published in January 1912 as a manifesto of the new idealism. And just one year after Crane wrote his piece on Stieglitz, T. E. Hulme could declare with the certainty of an eyewitness that a "consciousness of idealism" was the "predominate spiritual attitude of the 1920's."[20]

It is only too easy when examining the impact of one mind on another to lapse into the error of simplistic causation and thus attribute to a single incident such as Crane's encounter with Stieglitz's Apples and Gable a host of consequences for which it was only one of several precedents. We can say at very least that the event elicited a significant prose statement from Crane and that he correctly identified the fundamental idealism of Stieglitz's photographs, which sought not merely to portray objects but to reveal the cosmic essence of all things. "That is it," cried Crane. "You've captured life." Indeed Stieglitz had, and his victory spurred Crane's resolve to do likewise in poetry.

Crane also believed that all artistic endeavor is a shared experience, on a plane where, in Stieglitz's words, "all true things are equal to one another."

6

Thus Crane declared to Stieglitz, "I am your brother always,"[21] and said, without elaborating, that the photographer had entered "very strongly into certain developments of The Bridge."[22] These developments, whatever they were, must have lain in 1923 at the foundation of the epic.

Crane was not the only poet to be galvanized by Stieglitz's field of force. Another instance is documented in William Carlos Williams' Autobiography. Throughout this work Williams glosses over Stieglitz, and indeed over anyone else who might be thought to have influenced his poetry by furnishing him with ideas. But in the introductory remarks regarding his artistic pilgrimages to New York, he lowered his defenses a bit. He recalled that during these trips he would visit Stieglitz's gallery [probably An American Place], view the exhibits there, and talk with Stieglitz about art and music. "After that," Williams continues, "I'd come home and think--that is to say, to scribble. I'd scribble for days, sometimes, after such a visit, or even years, it might be, trying to discover how my mind had readjusted itself to its contacts."[23]

Providing just such contacts with avant-garde aesthetics was probably Stieglitz's major contribution to the artistic development of the writers who came to him. Sometimes the lesson was immediate: simple exposure to the works of modern art in Stieglitz's galleries for he was one of the first to exhibit them. Painters and writers alike regarded these rooms as oases in the American wasteland, as temples where Mammon had no shrine. Here Stieglitz's teaching sometimes took the form of his famous monologue, the "eternal talking" that Williams complained about elsewhere, a mixture of anecdotes, aphorisms, and parables.

One of Williams' "scribblings" resulting from his contacts with Stieglitz's world and indicating quite clearly the psychic refreshment of Stieglitz's places was "A Matisse," a prose impression published by Williams in his significantly named little magazine Contact. The first and last sentences suffice to convey the content and the tenor of the piece: "On the french grass, in that room on Fifth Ave., lay a woman who had never seen my own poor land. . . . In the

7

french sun, on the french grass in a room on Fifth Ave., a french girl lies and smiles at the sun without seeing us."[24]

"That room on Fifth Ave." seems at first glance to allude to Stieglitz's gallery at 291 Fifth Avenue, but it has yet to be established that Williams ever visited 291, which closed in 1917, though he did frequent The Intimate Gallery (on Park Avenue) and, repeatedly, An American Place (on Madison Avenue). The allusion is further complicated by the question of which particular painting Williams referred to. The Blue Nude seems to fit the description, and Stieglitz did indeed exhibit Matisse at 291 in 1908 (the first American showing), but Bram Dijkstra points out that "there is no indication that [The Blue Nude] was ever shown at 291 or anywhere else in New York during the 1910's." Dijkstra concludes that Williams more likely saw a reproduction of the painting in the August 1912 special number of Camera Work.[25]

There is yet another explanation, one that does not presume a lapse of memory by Williams: during one of his trips to New York in 1920 the poet probably visited the room at 293 Fifth Avenue maintained by Stieglitz after 291 closed, and there he saw Stieglitz's personal copy of The Blue Nude or perhaps a gravure pull of the Camera Work reproduction.

At any rate there can be little doubt that it was Stieglitz who provided Williams with the place in his "own poor land" where the poet could come into contact with the vitality--the "sun" and the "grass"--of European art. And Matisse's treatment of the nude was a promise of sanity in a land where, said Williams' sketch, "No man . . . has ever seen a woman naked and painted her as if he knew anything except that she was naked."

Despite, perhaps because of, Williams' indebtedness,[26] the poet's early reverence for Stieglitz changed to almost vitriolic bitterness by the time the photographer died in 1946. The cause of Williams' disaffection, as charged in his Autobiography and in the unpublished diatribe "What of Alfred Stieglitz," was the photographer's supposed mistreatment of Marsden

Hartley. Whether the offense actually occurred or was
merely imagined by Williams is debatable.[27] Behind the
poet's rancor also may have been a dispute over the
price set by Stieglitz on a John Marin painting that
Williams wanted.[28] What concerns us here, however, is
that a significant part of Stieglitz's effect on
Williams was that of a catalyst. Williams himself
admitted this effect, and it is clearly visible in his
work of the 1920's. The degree to which Stieglitz
impinged on Williams' consciousness is described by the
poet himself: "If the fit was on me--if something
Stieglitz or Kenneth [Burke] had said was burning inside
me, having bred there overnight demanding outlet--I
would be like a woman at term; no matter what else was
up, that demand had to be met."[29]

The _furor poeticus_ that Stieglitz aroused in
Williams took a more complex and frustrated form in Jean
Toomer. By 1924 the author of _Cane_ had become a full-
fledged member of the Stieglitz circle and joined such
regulars as Waldo Frank, Paul Rosenfeld, Gorham Munson,
and Hart Crane (to mention only the writers in the
group) when they dined with the master after sessions
in the room he then kept as a private gallery for him-
self and his friends. Toomer also found himself among
the Stieglitz crowd during Paul Rosenfeld's musical-
literary _soirées_.[30]

Stieglitz's photographs both unsettled and reassur-
ed Toomer. To begin with, they overturned his previous
assumptions about art. "Your work," he told Stieglitz,
"has started a series of fundamental questions, it has
been a challenge."[31] Yet this same work was for
Toomer a "high assurance": a guarantee in effect that
expressionistic art, including of course Toomer's
own writings, could endure even if it could not prevail
at a time when objectivity was the reigning mode. An
evening with Stieglitz was for Toomer, as for Hart
Crane, a quasi-mystical experience:

 Last night, after leaving you, I
 walked the streets in a strange
 deep peace, in a quiet dignity.
 Had I been unable to find a sin-
 gle word expressive of your art
 and you, these inward states

would have been my sure knowledge.
And they are yours, for at their
height you shared them, and at
their source I cannot distinguish
the "I" and "you."[32]

Here the catalyst precipitated, not creative
turmoil as in Crane and Williams, but the profound
quiescence that accompanies ultimate intuition. But
the writer in Toomer contended with the mystic. He
could not remain satisfied with these "inward states"
but felt compelled to express in words the enlighten-
ment he shared with Stieglitz. But for all his gifts
of expression, Toomer could not "reduce this experience
to a medium," even though he was adept in poetry, drama,
and fiction. Despairing of fully explaining what
Stieglitz's work meant to him, Toomer sent the photog-
rapher a copy of Cane inscribed, "To Alfred Stieglitz,
for whom an adequate inscription will be written in
that book which is equal to me."[33]

That no book truly commensurate with Toomer's
talent was ever produced is part of the tragedy of the
black writer in America, but to the credit of Stieglitz
and his friends let it be recorded that they recognized
Toomer's potential and did what they could to advance
his career. Paul Rosenfeld praised him in Men Seen
(1925), as did Gorham Munson in Destinations (1928).
The American Caravan, edited by Rosenfeld, Alfred
Kreymborg, and Lewis Mumford, printed Toomer's work
(in the second and third volumes), including his last
published fiction, the novella York Beach (1929). But
it was all in vain. Toomer's racial ambivalence never
resolved itself, and his predilection for mysticism
(seen so clearly in his relationship with Stieglitz)
carried him out of letters, into the transcendentalism
of French guru Charles Gurdjieff, and ultimately into
Quakerism.

CHAPTER 1

[1] Alfred Stieglitz, "Ten Stories," Twice a Year, nos. 5-6 (Fall-Winter, Spring-Summer 1940-41), p. 161.

[2] Ibid.

[3] AS to Paul Rosenfeld, Nov. 14, 1923. Unless otherwise noted, all letters are from the Alfred Stieglitz Archive, Collection of American Literature, Beinecke Rare Book and Manuscript Library, Yale University.

[4] Herbert J. Seligmann, Alfred Stieglitz Talking (New Haven: Yale Univ. Library, 1966), p. v; hereafter cited as Seligmann, AS Talking.

[5] Herbert J. Seligmann, "Burning Focus," Part 1, Infinity, Dec. 1967, p. 26.

[6] Gorham Munson, "291: A Creative Source of the Twenties," Forum, 3 (Fall-Winter 1960), 8.

[7] The essay appeared in Century, Aug. 1924, pp. 489-96.

[8] Sherwood Anderson to Waldo Frank [Dec. 1919], in Letters of Sherwood Anderson, ed. Howard Mumford Jones and Walter B. Rideout (Boston: Little, Brown, 1953), p. 51; hereafter cited as Letters of SA.

[9] For this information I am indebted to Professor Peter C. Bunnell of Princeton University.

[10] Herbert J. Seligmann, "291: A Vision Through Photography," in America and Alfred Stieglitz, ed. Waldo Frank et al. (Garden City, N.Y.: Doubleday, Doran, 1934), p. 113.

11 Sherwood Anderson to AS, [June 30, 1923]; in Letters of SA, p. 99.

12 Walter Pach, The Masters of Modern Art (New York: B. W. Huebsch, 1924), p. 37.

13 Sherwood Anderson, "Alfred Stieglitz," New Republic, Oct. 25, 1922, p. 215.

14 Brom Weber, "Stieglitz: An Emotional Experience," in Stieglitz Memorial Portfolio, ed. Dorothy Norman (New York: Twice a Year Press, 1947), p. 48.

15 Reproductions of Apples and Gable, Lake George (1922) appear in Dorothy Norman, Alfred Stieglitz: An American Seer (plate XLVII) and in Bram Dijkstra, The Hieroglyphics of a New Speech (plate X).

16 Hart Crane to AS, Apr. 15, 1923; in The Letters of Hart Crane, 1916-1932, ed. Brom Weber (Berkeley and Los Angeles: Univ. of California Press, 1965), p. 131; hereafter cited as Letters of HC.

17 Ibid.

18 For an expanded discussion of the ideas that Crane derived from Russian mystic P. D. Ouspensky, see Brom Weber, Hart Crane: A Biographical and Critical Study (New York: Bodley Press, 1948), passim.

19 Verse quotation from Blake's "To the Christians." Both Crane's "moment made eternal" and much later Henri Cartier-Bresson's "decisive moment" were preceded by Gotthold Lessing's einzige Augenblick. Lessing makes the important qualification that the "single moment" chosen by the artist must be "fruitful"; that is, it must permit maximum play of the imagination (Laocoön, [1766], chapter 3).

20 T. E. Hulme, Speculations (London: K. Paul, Trench, Trubner, 1924), p. 116.

[21] Hart Crane to AS, Aug. 11, 1923; in Letters of HC, p. 142. (Crane's italics)

[22] Hart Crane to AS, July 4,[1923]; in Letters of HC, p. 138.

[23] The Autobiography of William Carlos Williams (New York: Random House, 1951), p. xiii.

[24] Contact, No. 2, Jan. 1921, n. p.

[25] Bram Dijkstra, The Hieroglyphics of a New Speech: Cubism, Stieglitz, and the Early Poetry of William Carlos Williams (Princeton, N.J.: Princeton Univ. Press, 1969), p. 109, n. 5.

[26] For a thorough exploration of these debts, see Dijkstra, chapter 3 and passim.

[27] Dijkstra (p. 85) offers evidence that Stieglitz did not in fact "drop" or "kick" Hartley as Williams charged. But Paul Rosenfeld definitely alluded to Stieglitz's "quitting" Hartley (Paul Rosenfeld to AS, July 14, 1919).

[28] Dijkstra, p. 85.

[29] Williams, Autobiography, p. xiii.

[30] See Letters of HC, pp. 194-95, for a roll call of the guests at Paul Rosenfeld's reception for French critic Jean Catel.

[31] Jean Toomer to AS, [Jan. 13, 1924].

[32] Jean Toomer to AS, Jan. 10, 1924.

[33] Ibid.

CHAPTER 2

INSTRUMENT OF MEASUREMENT

Stieglitz as Appreciative Critic

Second only to Stieglitz's function as catalyst was his role as informal critic of the contemporaneous American literary scene. At first glance it might seem that Stieglitz was ill equipped to criticize literature because his reading was never systematic and because he was innately opposed to conventional methods of judgment. But his reading, though necessarily confined to rest periods away from his camera, was sufficiently extensive for purposes which, like those of the later New Critics, avoided comparative evaluations. Judging each book on its own merits, Stieglitz kept abreast of the latest releases, especially those of his friends, and he unerringly located the works in both literature and philosophy that supported the conclusions he had reached by instinct and intuition. Stieglitz's reading will be examined later in this study; for the time being it is his role as critic that concerns us.

Stieglitz's literary criticism appeared in two forms: appreciation and correction. The appreciative type was more consonant with his conviction that the deepest, indeed the only true knowledge is intuitive rather than discursive. Ideal criticism, it follows, is sympathetic appreciation tested against the touchstone of intuition—appreciation, that is, of the writer's motives and intentions (even if not fully realized) and intuition of the "spirit," the essential life, of the work. Sincerity, dismissed as irrelevant by formalist critics, became virtually synonymous with truth in Stieglitz's canon. As Hutchins Hapgood recalled from his own experience at the 291 gallery, "Those who heard and saw Stieglitz talk . . . know the passionate sincerity which moved him. . . . The simplest sincerity controlled him always and, so, affected his audience."[1] Stieglitz's comments also made it clear that he considered artistic achievement to be a direct corollary of organic vitalism, the "spirit" or "life" of the work under consideration.

Of the several recipients of Stieglitz's apprecia-

tive criticism, the most important was Sherwood Anderson. Stieglitz met him in 1919, and soon thereafter began reading his stories and novels as they came off the press. In his correspondence with Anderson from 1922 to 1938, Stieglitz comments specifically on Many Marriages (1923); the stories in Horses and Men (1923), especially "The Man Who Became a Woman"; A Story Teller's Story (1924); Dark Laughter (1925); Sherwood Anderson's Notebook (1926); A New Testament (1927); "Loom Dance" (New Republic, Apr. 30, 1930); Beyond Desire (1932); and Puzzled America (1935).[2] During these years Stieglitz did what he could to counter the decline of Anderson's reputation among the Eastern intellectuals, but clearly his most significant contribution to Anderson's career was the personal encouragement he gave the writer himself.

The distinctive quality of Stieglitz's critical approach to Anderson's fiction is best indicated by the photographer's own words. "There is Volume to all," Stieglitz declared after reading a section of A Story Teller's Story. "A roundness of sound--big--that of a deep baritone voice or a fine cello--or rather a group of cellos.--May be that expresses it best. In short fine music."[3] While professional critics were fretting over Anderson's disregard for chronological consistency and brother Karl Anderson was disputing the factual accuracy of the narrative, Stieglitz's intuitive perception led him straight to Anderson's basic lyricism.

Stieglitz was well prepared to recognize lyricism, for he himself, forswearing both the picturesqueness and the unintentionally deceptive realism of his early photographs, had progressed toward an increasingly lyrical mode of expression in his photography. Just two years before A Story Teller's Story had begun to be serialized, Stieglitz had produced his eloquently titled Cloud Music and Songs of the Sky series.[4] He could not have been more explicit as to the lyrical motivation of this group of near abstractions than when he wrote: "I wanted a series of photographs which when seen by Ernest Bloch (the great composer) he would exclaim: Music! Music! Man, why this is music! How did you ever do that? And he would point to violins, and flutes, and oboes, and brass, full of enthusiasm. . . . And when I finally had my series of ten photo-

CHAPTER 2

INSTRUMENT OF MEASUREMENT

Stieglitz as Appreciative Critic

Second only to Stieglitz's function as catalyst was his role as informal critic of the contemporaneous American literary scene. At first glance it might seem that Stieglitz was ill equipped to criticize literature because his reading was never systematic and because he was innately opposed to conventional methods of judgment. But his reading, though necessarily confined to rest periods away from his camera, was sufficiently extensive for purposes which, like those of the later New Critics, avoided comparative evaluations. Judging each book on its own merits, Stieglitz kept abreast of the latest releases, especially those of his friends, and he unerringly located the works in both literature and philosophy that supported the conclusions he had reached by instinct and intuition. Stieglitz's reading will be examined later in this study; for the time being it is his role as critic that concerns us.

Stieglitz's literary criticism appeared in two forms: appreciation and correction. The appreciative type was more consonant with his conviction that the deepest, indeed the only true knowledge is intuitive rather than discursive. Ideal criticism, it follows, is sympathetic appreciation tested against the touchstone of intuition--appreciation, that is, of the writer's motives and intentions (even if not fully realized) and intuition of the "spirit," the essential life, of the work. Sincerity, dismissed as irrelevant by formalist critics, became virtually synonymous with truth in Stieglitz's canon. As Hutchins Hapgood recalled from his own experience at the 291 gallery, "Those who heard and saw Stieglitz talk . . . know the passionate sincerity which moved him. . . . The simplest sincerity controlled him always and, so, affected his audience."[1] Stieglitz's comments also made it clear that he considered artistic achievement to be a direct corollary of organic vitalism, the "spirit" or "life" of the work under consideration.

Of the several recipients of Stieglitz's apprecia-

tive criticism, the most important was Sherwood Anderson. Stiegltiz met him in 1919, and soon thereafter began reading his stories and novels as they came off the press. In his correspondence with Anderson from 1922 to 1938, Stieglitz comments specifically on Many Marriages (1923); the stories in Horses and Men (1923), especially "The Man Who Became a Woman"; A Story Teller's Story (1924); Dark Laughter (1925); Sherwood Anderson's Notebook (1926); A New Testament (1927); "Loom Dance" (New Republic, Apr. 30, 1930); Beyond Desire (1932); and Puzzled America (1935).[2] During these years Stieglitz did what he could to counter the decline of Anderson's reputation among the Eastern intellectuals, but clearly his most significant contribution to Anderson's career was the personal encouragement he gave the writer himself.

The distinctive quality of Stieglitz's critical approach to Anderson's fiction is best indicated by the photographer's own words. "There is Volume to all," Stieglitz declared after reading a section of A Story Teller's Story. "A roundness of sound--big--that of a deep baritone voice or a fine cello--or rather a group of cellos.--May be that expresses it best. In short fine music."[3] While professional critics were fretting over Anderson's disregard for chronological consistency and brother Karl Anderson was disputing the factual accuracy of the narrative, Stieglitz's intuitive perception led him straight to Anderson's basic lyricism.

Stieglitz was well prepared to recognize lyricism, for he himself, forswearing both the picturesqueness and the unintentionally deceptive realism of his early photographs, had progressed toward an increasingly lyrical mode of expression in his photography. Just two years before A Story Teller's Story had begun to be serialized, Stieglitz had produced his eloquently titled Cloud Music and Songs of the Sky series.[4] He could not have been more explicit as to the lyrical motivation of this group of near abstractions than when he wrote: "I wanted a series of photographs which when seen by Ernest Bloch (the great composer) he would exclaim: Music! Music! Man, why this is music! How did you ever do that? And he would point to violins, and flutes, and oboes, and brass, full of enthusiasm. . . . And when I finally had my series of ten photo-

16

graphs printed, and Bloch saw them--what I said I wanted to happen happened verbatim."[5]

Critics eventually came to detect the lyrical spirit that is the common denominator of virtually all of Anderson's novels, tales, and poems;[6] and the author himself, when well past the midpoint of his career, acknowledged, "I've thought, all the years I've been writing, that if I'm any good at all, there should be music at the bottom of my prose."[7] Stieglitz was among the first to recognize and applaud the underlying musicality of Anderson's prose.

Anderson in turn responded to the basic lyricism of Stieglitz's photographs. "Both things sing," he wrote in a letter to Paul Rosenfeld (July 4, 1923) reporting that "that dear, dear Stieglitz" had made him a present of two prints. One of these photographs, Equivalent, Music No. 1, Lake George (1922), was still hanging on the wall of Anderson's Ripshin farm house near Marion, Virginia, when I visited there during the spring of 1974.

By styling himself a storyteller, Anderson located his work in the oral narrative tradition. But Stieglitz was not misled by labels, not even by self-applied ones. His freely orbiting sensibility enabled him to perceive that Anderson's "voice" was more important than the actual narrative and that Anderson had so saturated fact with emotional significance that his fiction became a rich orchestration of tonal effects. "I told Ettie Strettheimer the other night," Stieglitz related to Anderson after reading Dark Laughter, "that when I was through with it--I had forgotten the Story--the individuals in it--even the writing--I merely felt a great relaxed feeling & heard a marvelous Baritone Voice that seemed to grow rounder & bigger--fuller--more wonderful every moment."[8]

That intuition rather than training or reasoned judgment was the foundation of Stieglitz's credo is further emphasized by the sentence that immediately followed the statement about Anderson's voice: "Where thinking stops Art begins." This rather startling thesis was one of Stieglitz's favorite sayings; through

it he affirmed not mere anti-intellectualism but what might be called meta-rationalism. Reason admittedly had its place, but for Stieglitz it was not the ultimate human faculty; discursive thought was but an initial stage on the road to truth.

The depth of sympathetic understanding between Anderson and Stieglitz is nowhere better disclosed than in the letters they exchanged in 1923 and 1924. Anderson, when acutely aware of truth and beauty, was apt to burst into tears. It happened once in Paris as he was crossing the courtyard of the Louvre in the company of his patron, Paul Rosenfeld.[9] Another instance, one involving Stieglitz, occurred on a train as Anderson was riding through the Nevada countryside, forlornly awaiting his divorce from Tennessee Mitchell. Suddenly the thought of what Stieglitz's life had come to mean to him caused the author to "weep bitterly" and to turn his face from the other passengers for shame of his apparently causeless grief. Later Anderson described the incident to Stieglitz and explained that the outburst stemmed from his coming to realize Stieglitz's devotion to "cleanliness and health" in the "crafts," which of course for Anderson included the arts. This quality, said Anderson, had "registered" not only on himself but also on John Marin, Georgia O'Keeffe, and Paul Rosenfeld.[10] The theme of cleanliness and health in the productive life of man became, after maturing a couple of years in the author's mind, a principal motif in Dark Laughter (1925), the most popular of all of Anderson's novels.

Stieglitz's reply to Anderson's effusion vibrated with like emotion. He was genuinely touched by the author's outpouring of feeling:

> Well, dear Man, it was very wonderful to stand there [reading Anderson's letter] so alone under the clear blue sky & blazing sun--so full of pain & sorrow--so terrifically empty feeling--to read-- sense, in spite of all the tiredness & weariness & longing-for-a- great peaceness--a long, long, sleep--that there was a Man far

18

away who actually knew what <u>feeling</u>
meant & who could cry while <u>just</u>
thinking of another human being.[11]

Stieglitz at this time was sick and depressed, and
the receipt of this spiritual token from Anderson was,
he said, the cause of his "regaining strength gradually
[and] beginning to feel light within."[12] Thus in
unabashed openness two men of feeling met and saluted
each other as kindred spirits in a land where tough-
minded smartness had become the habitual pose of artists
and intellectuals alike.

More than emotional, Stieglitz's appreciative
criticism of Anderson's prose verged at times on the
visceral. After reading <u>A Story Teller's Story</u> (1924),
Stieglitz wrote:

> Every now and then I take a peep
> into its pages like a fellow goes
> to the cupboard & takes out a
> bottle & drinks a glass. . . . I
> have a copy of the book in differ-
> ent rooms [of the house at Lake
> George] so that I can peep as the
> impulse moves no matter what else
> I may be doing. And I always come
> away with an inner grin--like the
> fellow who has warmed up inside
> must grin to himself.[13]

Stieglitz would have been less than human if <u>A
Story Teller's Story</u> had not held a special place in his
esteem, inasmuch as a grateful Anderson had dedicated
the book to "Alfred Stieglitz, who has been more than
father to so many puzzled, wistful children of the arts
in this big, noisy, growing and groping America."
Anderson, moreover, had explained the dedication in
advance by telling Stieglitz, "There is so much of a
spirit of something--I have had clarified in me from
you--in this book that I would like, if you wouldn't
mind, to dedicate it to you, with a little appreciation
as a foreword."[14]

The spirit to which Anderson referred, however
haltingly, was doubtless the genial humanism that
permeates the book. Stieglitz sensed this quality from

19

the outset: "The humor is delightful--But what I enjoy
most is the loveable spirit running through the whole
book--a generous soul."[15] As he continued to reread
A Story Teller's Story--some of the pages "dozens of
times"--the photographer marveled, "He's a big man--
[and] has a real Soul. And that's what will continue
to live long after Menckenese cleverness is dead and
forgotten."[16] In the 1920's, however, the reading
public preferred smartness to soul. Anderson's book
sold poorly, soon went out of print, and was not revived
until the 1950's. But time may yet prove Stieglitz
right.

Stieglitz's comments on other works by Anderson
were generally terse but trenchant. "Alive" was the
term he most often chose for praising Anderson's work.
The word summed up the vitalism he saw imbuing Ander-
son's better fiction, his own photography, and indeed
all worthwhile art. And so it was not empty rhetoric
when Anderson chose the title "Seven Alive" for his
introduction to the 1925 exhibition of Stieglitz and
his group.[17] Somewhat earlier, Stieglitz, after
reading "The Man Who Became a Woman," had told the
author, "I hope there'll be a few others who'll get
some of what I got--the genuine beauty--the subtle
something men like you and myself feel to such an
extent that sometimes I wonder am I crazy."[18] Stieg-
litz went on to say that this elusive quality, the
hallmark of the "real artist," was nothing short of the
"intensest passion for life in its every living
sense."[19] For Stieglitz as for Anderson and Crane, art
was not an imitation of life but, paradoxically, life
itself.

The basis of Stieglitz's appreciation of Anderson
extended further than aesthetics; it included remark-
ably similar world views. This philosophical affinity
emerged quite clearly in a discussion they had about
the radical innocence of humankind, a discussion that
also revealed a fundamental difference in their temper-
aments.

> You see [Stieglitz wrote to Ander-
> son] all humans represent a Great
> Innocence to me--And that is the
> wonder I see. Even those Fools

who believe they run the world--the
affairs of men--All Innocent when
I'm alone with Each--All equally
wonderful. That's my madness to
feel that. Not as a theory. Not
as attitude. But just to feel that
exists & nothing more. Innocent as
the trees are innocent--& the vapors
that play about the Moon & that try
to hide the sun on a glorious morn-
ing like this.[20]

Going on to develop an antithesis like that between
William Blake's Songs of Innocence and Songs of Experi-
ence,[21] Stieglitz continued:

It is when men begin to do business
that innocence no longer exists--
when exploitation begins--when two
get together to do a third--& men
begin to talk Law & Justice & Votes
& Party--& nothing is felt--all
becomes muddy & ugly & messy--& so
unnecessarily as I see it.--
Inhuman.[22]

In his next letter to Stieglitz, Anderson promptly
turned his attention to the innocence theme, for this,
as he must have recognized, was the keynote of his
work in progress, A Story Teller's Story, an autobiog-
raphy steeped in Emersonian optimism.

In this book [Anderson informed
Stieglitz] I am trying to tell, as
plainly and clearly as I can, the
story of a man--myself--who found
out just about what you have out-
lined in your letter today.

You see, dear man, I have been
a long time finding out just that
people are really innocent, and it
may be that much more than you know
of what I have found out has come
to me because of a growing aware-
ness of you. Since I have known
you, your figure has been standing
all the time a little more and
more clear.[23]

But after admitting this affinity with and indebt-
edness to Stieglitz, Anderson went on to make a point
that marks a crucial distinction between the two men's
natural dispositions: "While a man may become aware of
the innocence of people in general, he cannot quite love
that innocence itself. One wants comrades, grown men
such as I have come to feel you, and Paul [Rosenfeld]
too."[24] Anderson could agree intellectually with Stieg-
litz's moral abstraction, but his deepest urge could be
satisfied only by flesh-and-blood humanity. Stieglitz,
on the other hand, seemed readier to love man as an
ideal. Indeed, one of the entries in the commonplace
book he kept as a student in Germany reads, "Die
Menschheit ist gross, und die Menschen sind Klein."[25]

Anderson, perhaps more than any other of Stieglitz's
literary friends, cemented a solid comradeship with the
photographer. At the very time when Waldo Frank was
charging Stieglitz with being incapable of accepting
anyone save as a disciple,[26] the master admitted that
Anderson and he were peers by virtue of their quest:
"I feel that you are after a similar thing [a truth
beyond ordinary realism] & are working it out in your
way as I work it out in my way."[27]

Stieglitz's role as Anderson's appreciative critic
included bolstering the author against the bad press he
began to receive after the publication of Many Marriages,
a novel that bemused the few readers it did not outrage.
Anderson was stunned by the attacks, especially when
the Dial, after awarding him its prize for literature in
1921 and after serializing Many Marriages in 1922,
published a retrospective review which was, as Anderson
recognized, a shamefaced apology for his work.[28]
Sensing Anderson's hurt, Stieglitz urged him to ignore
the Dial and the barbs of "that woman," critic Alyse
Gregory.[29] Stieglitz's defense in such matters was his
own version of Emersonian self-reliance, and here as
elsewhere he exhorted Anderson to believe that what is
deep is holy. Every atom of Anderson's being tended to
affirm this creed--until, that is, a reviewer came along
and demonstrated that what is deep may sometimes be
merely muddy.

But the spirit of Emerson rose in all its mystical
vigor in a letter that Stieglitz hastened to the author

after the publication of <u>A New Testament</u> in 1927
caused a reviewer to announce that Anderson was "sick
of words" and "dying before our eyes."[30] Anderson
tried hard to be stoical and to believe that such
"body-punching criticism" was a "good thing,"[31] but
blows of this kind tended to aggravate the periodic
depressions he suffered,[32] and he later admitted that
he was "always pleased with any sort of flattery" of
his writing.[33] He even asked his wife to read the
reviews and pass on to him only those that were kind.

This, then, was the all too vulnerable writer to
whom Stieglitz posted a message of self-trust sprinkled
with tropes worthy of the sage of Concord himself:

> Undoubtedly you are above all [that is]
> written about you--favorable or unfa-
> vorable.--Momentarily one may be
> affected--more personally than other-
> wise. One has no choice but to
> march ahead for better or worse--
> The inner eye moves toward the In-
> visible Star--one's Own.--That's
> all there is to it.[34]

But it was not that simple for Anderson; when it
came to relying on his own ego, he vacillated between
bravado and gnawing doubt. In the foreword to <u>Tar: A
Midwest Childhood</u> (1926), he announced with seemingly
unshakable resolution that he must be himself: "It was
only then [after creating the persona of Tar] I faced
myself, accepted myself. 'If you are a born liar, a
man of the fancy, why not be what you are?' I said to
myself, and having said it I at once began writing with
a new feeling of comfort." But a year later Anderson
was warning his son John about a certain young man:
"He was eaten up with contemplation of self. It had
grown on him like a disease."[35] This pathological
egoism, Anderson said, resulted from the sensitive per-
son's attempting to prolong the moments of acute con-
sciousness that are his natural endowment but that are
doomed to be moments only. Perhaps the latter conclu-
sion was an admission of the author's own instability.

A letter from Stieglitz, however inspiring, could
not permanently smooth Anderson's ingrained cycle of

moods. But, given the author's almost pathetic need for support, the encouragement of someone like Stieglitz, who seemed to stay on the crest of the wave, must have helped. And this help is no doubt what Anderson had in mind when he told his photographer friend, "I hardly think, dear man, that you can know how much you have meant to all of us, how much for example your letters to me this last year or two [1923-24] have meant."[36]

The interval of Stieglitz's most lavish encouragement of Anderson coincided, by fate or by chance, with the peak years of his appreciative criticism of Hart Crane. During the decisive 1923-24 period of the young poet's development, the impulsive Crane sped to his "brother" artist copies of whatever poem he happened to be working on, whether it was finished or not. In this fashion Stieglitz acquired a fragment of "For the Marriage of Faustus and Helen," an early version of the "Atlantis" section of The Bridge, and the complete "Voyages II."[37] Crane also saw to it that Stieglitz received a copy of White Buildings when it was published in 1926. In the accompanying letters Crane sometimes feigned nonchalance, saying of "Voyages II," for example, "Enclosed is one of a cycle of poems—love and sea poems I am writing—which may amuse you."[38] In his heart, however, he yearned for praise from the man he called the "purest living indice [sic] of a new order of consciousness."[39]

Stieglitz's critical liberalism was tested to the utmost by Crane's unconventional poems, and indeed on one occasion he admitted that the "strain" of the poet's "ambitious" efforts impeded enjoyment of the work.[40] But unlike such rationalists as Gorham Munson, who perceived that intuitions lay at the heart of Crane's meaning but who refused to accept such intuitions in the end because they might be "mistaken or even diseased" and because they lacked "certitude,"[41] Stieglitz put total faith in feelings—his own and those of trusted friends. After circulating among such confidantes the three stanzas Crane sent him of "For the Marriage of Faustus and Helen," Stieglitz reported to the author, "All felt something deeply moving. And all wished to read again and again."[42] Stieglitz saw the folly of attempting to make discursive statements about the kind

of poetry that by design had taken leave of conventional logic and syntax. With such work, feeling could furnish the only touchstone, and Stieglitz was well endowed with that faculty.

In one instance, however, Stieglitz's emotional response to Crane's poetry almost got out of hand. A letter written by Stieglitz to Crane after several readings of "For the Marriage of Faustus and Helen" and the early "Atlantis" poem, had to be destroyed because, as Stieglitz later told the poet, it was too "sentimental."[43] And to insure that his favorable response to these poems had not been the result of his "frightful tiredness" that summer, Stieglitz reread them when he felt stronger. His final verdict: "They stand. I like the spirit."[44]

On the surface Crane's brashness might be mistaken for utter self-confidence, but underneath he was just as vulnerable as Anderson. The poet was especially irritated by the seemingly malicious obtuseness of men like Matthew Josephson and Kenneth Burke who championed the mundane realism that Crane and Stieglitz in their respective media were trying to supersede.[45] In response to Crane's anxiety about finding an enlightened audience, Stieglitz sent him a paradoxical definition of artistic integrity that verged on solipsism:

> The trouble with most writers,
> painters & photographers . . . that
> I know is that while producing they
> are conscious of a public--they are
> thus _self_-conscious, not knowing
> the public--the _real_ public.--If I
> am my own public--then I know there
> _is_ a public that I am serving--which
> eventually will appear even if
> unseen.[46]

Stieglitz here is telling Crane what Emerson said more imperatively in "Self-Reliance": "Speak your latent conviction, and it shall become the universal sense; for the inmost in due time becomes the outmost." But Crane was not inner-directed enough to be satisfied for very long with such abstract principles. Like Anderson, he could forgo popularity but he craved comrades in art. And so he continued to stress his

brotherhood with kindred spirit Stieglitz.

In his last extant letter to the photographer, Crane summed up his personal view of Stieglitz's significance: "I read of exhibitions occasionally and I wish I were in town to look; and to talk with you."[47] One cause, or at least a precondition, of the poet's eventual suicide was his self-imposed exile in a place far from such touchstones as Stieglitz--a willful and fatal isolation, that is, from persons who were true enough in themselves to have been able to relieve the weight of despairing self-doubt that ultimately plunged him into the depths of the Atlantic.

In his relationship with Crane, as with Anderson, Stieglitz functioned above all as the "useful critic." Such a person, according to Alfred Kazin, who coined the term, can "usefully show the impact on his consciousness of another's artistic power."[48] Kazin no doubt was thinking of the critic in relation to the public, but Stieglitz's usefulness operated in the opposite direction, signaling to the artist himself the degree of his power.

Along the same line, Stieglitz thought of the visitors to his galleries as "instruments of measurement": by revealing their emotions in the presence of a picture, they corroborated the artist's intention.[49] In like manner Stieglitz became an instrument of measurement for the writings of Anderson and Crane, indicating how much "livingness" they contained. He may not have had the means or even the inclination to publicize his literary friends as a conventional critic would, but with true economy of spirit, Stieglitz spent his energy wisely by registering and "usefully" showing to the artists themselves the emotional impact of their work.

Like Stieglitz's letters to Anderson and Crane, those he wrote to Waldo Frank and Paul Rosenfeld were leavened with praise and encouragement. But Stieglitz found it much easier to compliment Rosenfeld than Frank. The latter was often called to task, sometimes without complete justification on the master's part; his very demeanor at times offended Stieglitz. When, for example, Frank's City Block appeared in 1922, Stieglitz directed his attention, not to the novel itself (being

he said, "much too busy" to read it thoroughly), but to matters that anyone else would have considered minutiae. Thus he denounced the folio brackets enclosing the page numbers, even though he admitted being pleased in general with the physical book, a limited edition whose handsome presswork perhaps reminded him of his own superb Camera Work journal. But why, one wonders, did he hold Frank accountable for typographical practices? The answer is that Stieglitz deemed the artist responsible for every detail of his work, and Frank, moreover, had personally edited City Block.[50]

But what especially incensed Stieglitz about City Block was the list of other books by Frank that appeared in the front matter. That, said Stieglitz, was a "slap in the face":

> The announcement page of the Author's works is a terrible blemish [the photographer grumbled to Paul Rosenfeld]. It should have been done with greatest care--the particular page--particularly where it is featured.--Real Frankian I fear.--Too tired--or something--to see all the way through.[51]

This was not the only time that Stieglitz charged Frank with carelessness, and sometimes the author had to admit it. But here the "terrible blemish" is a publisher's convention and scarcely merited the ire it attracted. The author himself, fumbling for an excuse, protested that the page was merely a "French custom" and a carryover from his earlier publications abroad.[52] To the objective observer, however, Stieglitz's demurral here seems rather picayunish.

Less carping was Stieglitz's reaction to Frank's social criticism. The public, in his own day and in the present, has valued Frank's commentaries on our society more highly than his novels, and Stieglitz anticipated that preference. Like most Americans, Stieglitz relished Frank's analyses of our culture and merely tolerated his fiction.

Two of Frank's ventures in social criticism boldly usher in his photographer friend as a combined messiah and culture hero: Our America (1919) and The Re-discov-

ery of America (1929). Stieglitz, humanly enough, was
a bit overwhelmed by the two encomiums. But regardless
of any subjective appeal, the intellectual power and
the integrity of these works raise them well above the
average of Frank's productions, as Stieglitz no doubt
recognized.

But Stieglitz's critical judgment of Frank had its
lapses. The photographer was inordinately fond, for
example, of the series of profiles (one of Stieglitz
himself) that Frank wrote pseudonymously for the New
Yorker and later collected in Time Exposures by "Search-
Light" (1926). The author himself regarded the profiles
as journalistic potboilers, and he chided Stieglitz,
albeit gently, for the "undue weight" the photographer
gave them.[53]

Stieglitz must have appreciated Frank's attempt
(confused though it was) to use a photographic metaphor
in these "time exposures," although in his letters he
did not comment on it. Instead, Stieglitz said that the
personal profile made him laugh, that the writing was
"corking" and "really rich."[54] Stieglitz's delight in
this essay reveals the often overlooked humorous side
of his nature, and probably Frank's ironic tone and
iconoclastic spirit here appealed to him. Not many of
Stieglitz's followers ever dared to mock the master,
but Frank, wearing the cap and bells of "Search-Light,"
boldly satirized Stieglitz's oral compulsiveness:

> Once, long before the Gallery of 291,
> in the days when Stieglitz was put-
> ting photography "on the map," he
> he went to London purposely to talk
> to Bernard Shaw who had said some
> silly things on the subject. He
> caught cold on the channel and when
> he arrived at his hotel, he had
> lost his voice. He was lunching
> with Shaw on the morrow. He wired,
> breaking his engagement and left
> England at once. Unable to talk to
> Shaw, he did not wish to see him:
> he did not wish to hear Shaw talk
> to him.[55]

When Stieglitz confronted Frank's fiction, the objectivity of his criticism was enhanced by the fact that he never appeared in any guise in the novels. Given this "distance," he accurately detected both the merits and the blemishes of his friend's creations, and his decisions in this area have been supported by history.

Just getting through one of Frank's novels often required all of Stieglitz's considerable determination. From time to time in his letters to Frank, Stieglitz would mention that he had begun or was in the process of reading a certain novel, and was enjoying it, but it often took him several months to reach the last page. The Dark Mother is a case in point. Stieglitz received a copy in October of 1920, but did not finish it until the following July. (One must bear in mind, of course, that the burden of affairs in New York made it necessary for him to postpone serious reading until he reached his summer sanctuary at Lake George.

Stieglitz's initial feeling about The Dark Mother was a "double thing," a mixture of "pleasure and displeasure";[56] and, although he defended the novel against the gibes of Sinclair Lewis and other journalists, his final verdict remained ambivalent. "It's certainly a book far above the usual one," he reported to the author. "There are pages that are extraordinary-- passages that are intensely beautiful--very living in the deepest sense."[57] But these, he added, were offset by "soft spots." And he was annoyed by the novel's ubiquitous breast motif. (Paul Rosenfeld informed readers of Men Seen that "The Dark Mother, like Diana of the Ephesians, is full of breasts.")[58] Because of the novel's unevenness, Stieglitz suggested that Frank rework it in five or ten years and turn it into a truly great book, since the original version had potential and good parts. But Frank never revised The Dark Mother, and, consonant with Stieglitz's estimate, a recent Frank scholar concludes that "the novel remains a collection of brightly polished parts."[59]

With Paul Rosenfeld, Stieglitz had a simpler task. His persistent message to this writer was, in effect, finish what you are working on and ignore anyone who impedes your work or tries to compromise its integrity.

In addition to urging Rosenfeld to stop tinkering with the essays he selected for the Port of New York (1924) collection, Stieglitz also encouraged him to finish some of the several novels he had aborted. But here Stieglitz's goading was only partly effective, for Rosenfeld managed to complete but one volume of fiction, an autobiographical novel called The Boy in the Sun (1928). Stieglitz's rather injudicious praise of this novel caused Rosenfeld momentarily to consider a career in fiction. But in his own mind Rosenfeld knew his strengths and weaknesses. "Sometimes," he confessed to Stieglitz at the very outset of his career, "I don't think I shall ever be a creative writer. I sometimes think that I shall turn out to be the sort of person who, when someone else does something good, comes out to meet it."[60] And indeed throughout his life, Rosenfeld served as the genial celebrant of other people's talent.

Stieglitz's sense of artistic discipline blazed out in response to Rosenfeld's complaints that house guests were disturbing his writing: "You dare let nothing interfere with that work of yours," Stieglitz thundered.[61] And despite his own revisions of Rosenfeld's writings (to be considered later in this study), he had no patience with others who tried it. "Yes, write what you feel," he commanded apropos of Rosenfeld's essay on Arthur Dove. "To hell with all the twaddle of the 'painters' & Co.--what they say is usually meaningless--most of it based on their own vanity & envy--prejudice, etc."[62]

This advice, reflecting again Stieglitz's over-riding conviction that the artist must always express his own uniquely felt experience, was indeed sound, though the master was not usually so vituperative. Rosenfeld's criticism excelled precisely when it was the most organic, when, like Emerson's temples, it "grew as grows the grass," pullulating from a consciousness where elegant sense impressions flowered into the very essence of the subject. These felt ideas Rosenfeld then projected with his splendidly emotive prose. As Herbert J. Seligmann put it, he "devoted his life to rendering to others an equivalent of his acute perceptions and exquisite experience."[63] Rosenfeld's essays in criticism, then, were the equivalents of his sensuous life just as Stieglitz's photographs were equivalents of his

emotions. Given Rosenfeld's discipleship of Stieglitz, the quality of equivalence in his prose could hardly be coincidental, especially since Rosenfeld, one of the best theoreticians of Stieglitz's art, was well versed in the doctrine of the equivalent, a theory to be examined later.

Like Anderson and Crane, Rosenfeld had his periods of depression and turned to Stieglitz for reassurance. At one point the photographer counseled him: "Your star is in the ascendant. By that I mean you will become appreciated. This appreciation will take practical form.--I'm sure.--It is inevitable."[64] To this, Rosenfeld replied, "Last night I was on the verge of suicide, but today am in the kind of trance which has sent me through town smiling the last weeks."[65]

It would be exorbitant to claim that Stieglitz literally saved Rosenfeld's life. The author himself interpreted this "unnoticeable transition of moods" as the natural rhythm of life. And although Stieglitz's faith heartened him, he knew that his star was destined to glimmer fitfully: "I am much obliged for the attention you pay," he told Stieglitz, "and the hope and confidence you show; perhaps without it I should not be so easily contented to have the star disappear behind the clouds from time to time."[66] Without Stieglitz's trust to compensate for the fame that Rosenfeld wanted but could not find, the young man might not have persevered as a writer, and our literature would be the poorer for it.

All in all, the most ubiquitous and abiding characteristic of Stieglitz's criticism of his friends' writings was his reliance on intuition. Stieglitz approached all art, including photography and literature, in the manner of a seer, as Dorothy Norman emphasizes in her book.[67] Thus when Frank fretted over the obvious differences between what he seemed to know and what he actually accomplished in such works as The Re-discovery of America, Stieglitz shored up the author's tottering self-confidence:

> I feel that in spite of the "short-comings" your book will undoubtedly have--the book will be of real

importance--a force in the right
direction--How do I know?--How can
I be so sure?--For the same reason I
know whether a photograph of mine is
true or not.--And I do know that.[68]

Untrammeled by academic canons of criticism,
Stieglitz moved freely among the arts, his intuitive
faculty serving as a bridge. For him the truth of a
book was as immediately perceptible as that of a
photograph, or a painting for that matter.

NOTES

CHAPTER 2

[1] Hutchins Hapgood, <u>A Victorian in the Modern World</u> (1939; rpt. Seattle: Univ. of Washington Press, 1972), p. 338.

[2] I have found no evidence that Stieglitz read <u>Winesburg, Ohio</u> or Anderson's earliest novels. Paul Rosenfeld referred to "the Anderson novel" (probably <u>Poor White</u>) in a letter to Stieglitz on Sept. 19, 1921; and Stieglitz himself mentioned hearing some "amusing discussions" of <u>Many Marriages</u> (1923); but apparently <u>Horses and Men</u> (1923) was the earliest fiction by Anderson that Stieglitz actually read.

[3] AS to Sherwood Anderson, June 26, 1924. Stieglitz was commenting specifically on the installment of <u>A Story Teller's Story</u> that appeared in the little magazine <u>Phantasmus</u> in June 1924.

[4] Stieglitz's 1923 <u>Songs of the Sky</u> series is reproduced in Doris Bry, <u>Alfred Stieglitz, Photographer</u> (Boston: Museum of Fine Arts, 1965), n. p. Stieglitz rejected <u>Music of the Spheres</u> as a title for this series because he considered the phrase too "ambitious"--his term for "pretentious" (AS to Paul Rosenfeld, Sept. 6, 1924).

[5] Alfred Stieglitz, "How I Came to Photograph Clouds," <u>Amateur Photographer and Photography</u>, 56, no. 1819 (Sept. 19, 1923), 255; reprinted in <u>Photographers on Photography</u>, ed. Nathan Lyons (Englewood Cliffs, N.J.: Prentice-Hall, 1966), p. 112.

[6] See, for example, Norman Holmes Pearson, "Anderson and the New Puritanism," <u>Newberry Library Bulletin</u>, 2nd ser., no. 2 (Dec. 1948), pp. 61-62.

[7] Sherwood Anderson to H. S. Kraft and Louis Gruenberg, [before March 31, 1933]; in <u>Letters of SA</u>, p. 283.

[8] AS to Sherwood Anderson, Dec. 9, 1925. Compare Walter Pater's conclusion that all arts aspire to the condition of music.

[9] Paul Rosenfeld to AS, June 13, [1923].

[10] Sherwood Anderson to AS, June 30, 1923; in Letters of SA, p. 99. A remarkably similar incident occurs in the story "The Sad Horn Blowers," which Anderson published some four months prior to writing Stieglitz about the real episode. Could this be an example of life imitating art?

[11] AS to Sherwood Anderson, July 23, 1923.

[12] Ibid.

[13] AS to Sherwood Anderson, Oct. 27, 1924.

[14] Sherwood Anderson to AS, June 25, 1923. From a typed copy in the Beinecke Rare Book and Manuscript Library; original in the Newberry Library.

[15] AS to Paul Rosenfeld, Oct. 8, 1924.

[16] AS to Paul Rosenfeld, Oct. 27, 1924.

[17] Sherwood Anderson, "Seven Alive," Dial, 78 (May 1925), 435-36. "The Seven" consisted of Arthur Dove, Marsden Hartley, John Marin, Charles Demuth, Paul Strand, Georgia O'Keeffe, and Alfred Stieglitz.

[18] AS to Sherwood Anderson, Nov. 1, 1923.

[19] Ibid.

[20] AS to Sherwood Anderson, July 30, 1923.

[21] In Stieglitz's letter to Paul Rosenfeld on July 12, 1924, Blake is mentioned as one of the writers who

confirmed Stieglitz's experiences in life and his objectives in art.

22 AS to Sherwood Anderson, July 30, 1923.

23 Sherwood Anderson to AS, [Aug. 6, 1923]; in Letters of SA, p. 106.

24 Ibid.

25 This quotation was taken from German-Jewish political writer and satirist Ludwig Börne and appears as entry no. 90 in a small notebook of Stieglitz's labelled Extracts, etc. Begun November, 1884, and now deposited in the Beinecke Rare Book and Manuscript Library.

26 Waldo Frank to AS, July 31, 1923.

27 AS to Sherwood Anderson, Aug. 15, 1923.

28 Alyse Gregory, "Sherwood Anderson," Dial, 75 (Sept. 1923), 242-46. Anderson commented on this article in his letter to Van Wyck Brooks, [early Oct. 1923]; in Letters of SA, p. 109.

29 AS to Sherwood Anderson, Sept. 25, 1923.

30 Lawrence S. Morris, "Sherwood Anderson: Sick of Words," New Republic, Aug. 3, 1927, pp. 277-79.

31 Sherwood Anderson to Stark Young, [mid-Aug. 1927]; in Letters of SA, p. 174.

32 Just two months after Alyse Gregory's attack, Anderson told Stieglitz that he was in a "horrible depression," which he attributed in part to "little spiteful things . . . said here and there" (Letters of SA, p. 113).

33 Sherwood Anderson, <u>Sherwood Anderson's Memoirs</u> (New York: Harcourt, Brace & World, 1942), p. 341.

34 AS to Sherwood Anderson, Aug. 11, 1927. Compare Emerson's "Man is his own star" in the epigraph to "Self-Reliance."

35 Sherwood Anderson to John Anderson, [late 1927]; in <u>Letters of SA</u>, p. 182.

36 Sherwood Anderson to AS, July 26, 1924; from a typed copy in the Beinecke Rare Book and Manuscript Library.

37 See Hart Crane to AS, April 23, 1923; July 4, [1923]; and Dec. 21, 1924. That of July 4, [1923], appears in <u>Letters of HC</u>, pp. 137-39.

38 Hart Crane to AS, Dec. 21, 1924.

39 Hart Crane to AS, July 4, [1923]; in <u>Letters of HC</u>, p. 138

40 AS to Waldo Frank, March 7, 1933. "Ambitious" was a pejorative word for Stieglitz; to him it meant "pretentious."

41 Gorham Munson, <u>Destinations: A Canvas of American Literature Since 1900</u> (New York: J. H. Sears, 1928), p. 175.

42 AS to Hart Crane, April 27, 1923; Columbia Univ. Library. The friends were Georgia O'Keeffe, John Marin, and a young Stieglitz disciple named Emil Zoler.

43 AS to Hart Crane, July 27, 1923; Columbia Univ. Library. Stieglitz here blamed his emotionalism on his "German antecedents."

[44] AS to Hart Crane, Aug. 15, 1923; Columbia Univ. Library.

[45] For further explanation of the Crane-Josephson antagonism, see John Unterecker, Voyager: A Life of Hart Crane (New York: Farrar, Straus and Giroux, 1969), pp. 305-06. Crane's indictment of Burke's seeing only the surface of Stieglitz's work is found in his letter to Stieglitz, Dec. 5, 1923; in Letters of HC, p. 158.

[46] AS to Hart Crane, July 27, 1923; Columbia Univ. Library.

[47] Hart Crane to AS, Dec. 27, [1926].

[48] Alfred Kazin, "The Useful Critic," Atlantic, Dec. 1965, p. 80.

[49] Seligmann, AS Talking, p. 35.

[50] When helping Herbert J. Seligmann edit Marsden Hartley's collection of essays, Stieglitz also concentrated on the physical features of the work. Returning the proofs of Adventures in the Arts to Seligmann, Stieglitz said in his cover letter, "I went over the make-up specially. . . . I read the reading matter only hastily--that is, some was read carefully, some not so carefully" (AS to Herbert J. Seligmann, Aug. 9, 1921; Stieglitz's italics).

[51] AS to Paul Rosenfeld, Oct. 4, 1922. Rosenfeld published his scathing estimate of Frank's fiction in "The Novels of Waldo Frank," Dial, 70 (1921), 99-105.

[52] Waldo Frank to AS, [Sept. 29, 1922].

[53] Waldo Frank to AS, April 18, [1927].

[54] AS to Waldo Frank, April 15, 1925.

[55] Waldo Frank, _Time Exposures by "Search-Light"_ (New York: Boni & Liveright, 1926), p. 177.

[56] AS to Waldo Frank, Oct. 18, 1920.

[57] AS to Waldo Frank, July 10, 1921.

[58] Paul Rosenfeld, _Men Seen: Twenty-four Modern Authors_ (New York: L. MacVeagh-The Dial Press, 1925), p. 95.

[59] Paul J. Carter, _Waldo Frank_ (New York: Twayne, 1967), p. 43.

[60] Paul Rosenfeld to AS, Aug. 30, 1920.

[61] AS to Paul Rosenfeld, Aug. 31, 1923.

[62] AS to Paul Rosenfeld, July 17, 1923.

[63] Herbert J. Seligmann, "Plowman of the Future," in _Paul Rosenfeld: Voyager in the Arts_, ed. Jerome Mellquist and Lucie Wiese (New York: Creative Age Press, 1948), p 240.

[64] AS to Paul Rosenfeld, June 7, 1926.

[65] Paul Rosenfeld to AS, June 13, 1926.

[66] Ibid.

[67] Dorothy Norman, _Alfred Stieglitz: An American Seer_ (New York: Random House, 1973).

[68] AS to Waldo Frank, Aug. 28, 1928.

CHAPTER 3

THE MASTER'S HAND

Stieglitz as Corrective Critic

To treat Stieglitz's role as an appreciative critic
as if it were completely divorced from the functions of
correction and deliberate guidance would be a gross
oversimplification. In surveying Stieglitz's relation-
ship with Waldo Frank and Paul Rosenfeld I noticed
several instances in which Stieglitz appeared to violate
his premise that every true artist must be free to
chart his own unique course toward the artistic ideal,
to follow his "Invisible Star," as Stieglitz symbolized
the quest for Anderson's benefit. Indeed the photogra-
pher granted that Frank and Rosenfeld were artists in
the deepest sense of the word; but when they wrote on
subjects in which Stieglitz had a proprietary interest--
himself or his protégés--the master did not hesitate to
correct whatever missteps he thought he detected, some-
times with unfortunate bluntness. His posture when
dealing with Frank and Rosenfeld was decidedly more
magisterial than with Anderson and Crane; perhaps, being
closer to Frank and Rosenfeld in many ways, he felt more
responsible for them. But in Frank's eyes the lofty
attitude maintained by Stieglitz was infuriatingly auto-
cratic. "I feel that you are incapable of a relation-
ship of equality with anyone," Frank finally railed at
the man he had once saluted as Cher Maître.[1]

At the time of this outburst, Frank was annoyed
specifically by Stieglitz's tendency to say slighting
things about him to such mutual friends as Hart Crane
and actor Rollo Peters, things which had a way of get-
ting back to Frank. But Frank's complaint was also
justified, at least from his own point of view, by
Stieglitz's incursions into his literary career. One
such incident involved an article on Georgia O'Keeffe
that Frank had written for McCall's magazine. Often
pressed by editorial deadlines and feeling in any event
that he had proven his competence, Frank was not in the
habit of clearing manuscripts with Stieglitz before
publication; but on this occasion H. P. Burton of
McCall's sent Stieglitz a copy of the O'Keeffe article
in order to get one of her paintings to use as an

illustration. The next day Stieglitz got off a sting-
ing reprimand to Frank accusing him of "tiredness,"
distortion of the facts of O'Keeffe's career, and
uncommonly bad writing throughout the article.[2]

By then Frank had sailed for Europe, and the letter
did not catch up with him for more than two weeks.
Replying from Paris in a tone of hurt but rather bellig-
erent confusion, Frank said that his first impulse upon
receiving Stieglitz's letter had been to recall the
article and correct the disputed facts. But, he con-
tinued, he decided not to attempt the recall because he
thought that undoubtedly the article was already in
print. Besides, said Frank, Stieglitz's criticism was
so general that correction would mean withdrawal of the
whole article, a course that would injure, Frank feared,
his "entire young relation with McCall's." The author
went on to point out that the facts in question had
come originally from Stieglitz himself, admitting that
memory might have distorted them. Frank then thrust to
the heart of the matter: he reminded Stieglitz that the
article was a critical interpretation and as such
depended upon the judgment of the writer, who must and
would accept the consequences of his words. What most
puzzled him, Frank added, was the fact that Stieglitz
"seemed very positively to approve" his interpretation
of O'Keeffe in a previous article (a New Yorker profile
later reprinted in Time Exposures). Frank felt that
there was no "acute discrepancy" between the two
accounts. He ended by saying, "I regret bitterly to
have hurt you, and in such a circumstance where to
change the article is virtually impossible."[3]

Stieglitz promptly rejoined that the facts he
objected to were those in Frank's account of how
O'Keeffe's drawings came into Stieglitz's hands through
an intermediary.[4] Frank's version, said Stieglitz, was
contrary to O'Keeffe's spirit. Speaking then to Frank's
right to his own independent judgment, Stieglitz
defined the limits of tolerance:

> I never quarrel with the artist.
> That is, I accept his premises.
> And so, accepting your premises
> re[garding] Georgia in Time Expo-
> sures, I enjoyed what you wrote,

> for it was well done. But that did
> not mean that I agreed with your
> premises. And there is no reason
> that I necessarily agree.[5]

All this, said Stieglitz, Frank should have comprehend-
ed without Stieglitz's having to say it. "If you don't
by this time understand my mechanism," the photographer
concluded, "you never will understand it."[6]

The mainspring of Stieglitz's mechanism was his
conviction that all true art is based on individualism.
Hence he had no choice but to grant Frank's premises,
whatever they were. But it did not follow that Stieg-
litz's own principles had to conform to any standard of
truth except his own. Here as elsewhere Stieglitz
seems to be saying that each person pursues a separate,
even divergent, path to truth, guided only by his own
subjective polestar. Was Stieglitz, then, a mere rela-
tivist? Only superficially. In Stieglitz's teleology,
the only absolute factor in life and art was the supreme
order imposed by fundamental laws. These laws might be
temporarily veiled by what Melville called the banality
of surfaces, but in the end they would predominate.
Thus he could give Frank carte blanche in all things
except the distortion of facts.

From Marseilles Frank replied, two weeks after
Stieglitz's letter, that he accepted "intellectually"
the comments on the O'Keeffe article, adding that,
if he should be expected to understand Stieglitz's
mechanism without further aid or explanation, then
Stieglitz should, by the same token, understand his
"spirit." However, Frank gave no indication that now
he would even attempt to withdraw the article from
McCall's. Unwilling to jeopardize a source of desper-
ately needed income, he seemed finally to decide that
the O'Keeffe article was an accomplished fact.

But the end of the incident is curiously indetermi-
nate. The disputed article in fact never appeared in
McCall's. Nor can the manuscript be found among Frank's
papers at the University of Pennsylvania. And when I
asked Georgia O'Keeffe, she had no recollection of the
article or of the dispute that it generated. She could
only suggest that perhaps neither Stieglitz nor Frank

said anything to her about the controversy because they did not wish to involve her in any unpleasantness.

In any event, while the two men were still arguing about the O'Keeffe article, Frank's "Alfred Stieglitz: The World's Greatest Photographer" appeared in <u>McCall's</u> (May 1927). The essay, as the title indicates, was extremely laudatory, and here Frank apparently had his facts straight. The master signified that he was well pleased, and peace returned for a time to this tempestuous friendship.

Stieglitz's alleged hindrance of Frank's career had been the occasion for an earlier, even more distressing conflict between the two friends. But this misunderstanding was actually the result of Frank's impetuosity. The incident is particularly fruitful for examination because it illustrates the high regard that even established writers had for Stieglitz's patronage.

As an exhibitor and later tenant at the Anderson Galleries, Stieglitz had become friends with the firm's president, Mitchell Kennerley. Prior to issuing Frank's third novel, <u>Rahab</u>, his publisher apparently arranged for Kennerley to review the book for the <u>New York Times</u>. Frank, soon to sail for Europe and knowing of Stieglitz's warm relations with Kennerley, asked the photographer to make sure that he received a review copy of the book. The author no doubt felt that Kennerley's known admiration for Stieglitz would insure a sympathetic reading. But when the <u>Times</u>' review came out, it was a banal, anonymous reader's report rather than the leg-up that Frank had anticipated. He was mortified, and upon discovering that <u>Rahab</u> had not been delivered to Kennerley until some months after publication, the author turned his wrath upon Stieglitz. In a letter that was almost a criminal indictment, Frank accused the photographer of sabotaging a "pivotal and strategic chapter" of his career by not inquiring whether Kennerley had received <u>Rahab</u>. Frank ended his tirade by denouncing Stieglitz's behavior as "shameful and detestable in its selfishness and indifference."[7]

Stieglitz's reply dashed ice water on Frank's tantrum. "Your letter I have shown to Kennerley without

comment," Stieglitz replied in a disdainful, pencil-written note. "You do not know that he was critically ill for four weeks & that he is just beginning to be himself." With a touch of vindictiveness, justified perhaps by Frank's rage, the photographer continued, "I feel that he was entitled to the privilege of seeing what you had written. I also showed Georgia [O'Keeffe] the letter--Furthermore I have nothing to add." The note closed with clenched-teeth formality: "Sincerely, Alfred Stieglitz."[8]

Nothing can damage a deep and loving friendship as disastrously as a simple misunderstanding, and heated words once uttered can never be retrieved. It is doubtful that a favorable review by Kennerley or by anyone else would have saved Rahab; the novel was one of a series of Frank's commercial failures that even-tually cost his publisher almost $10,000.[9] But the Kennerley affair seriously interrupted the rapport between Stieglitz and his volatile protégé. Their letters ceased for seventeen months, and a reconcilia-tion was not effected until Frank's tribute to the "world's greatest photographer" appeared in the New Yorker in the spring of 1925.

Unlike the sometimes truculent Waldo Frank, Paul Rosenfeld not only welcomed Stieglitz's corrective criticism, he actively solicited the master's guidance. He submitted manuscripts to Stieglitz before publication and invariably deferred to the photographer's judgment. If any of Stieglitz's followers can be said to have idolized him, that man was Paul Rosenfeld. "You are the only great artist [the] U.S.A. has produced since Walt Whitman," Rosenfeld told Stieglitz at the outset of an era in which he was to become a virtual publicist for the Stieglitz group, though functioning primarily as a music critic.[10]

Perhaps the most arresting example of Rosenfeld's malleability occurred after the author had achieved a substantial literary reputation and thus found himself in more or less the same situation which tempted Waldo Frank to cut loose from Stieglitz. Not so the mild-mannered chronicler of the musical scene. Having by 1933 won modest fame for his impressionistic essays on music and the visual arts, Rosenfeld was invited to

place his autobiography in a new collection of authors' lives. Accordingly he prepared what he considered a faithful summary of his career. He then asked Stieglitz for a portrait to accompany the article.[11] Stieglitz complied, choosing one of the studies he had previously made of the author. When Rosenfeld saw the photograph, he was nonplused: it was as if the autobiography and Stieglitz's image involved two different people. "I am glad to have the photograph," Rosenfeld told its maker, "for even if it is fearfully earnest and unsmiling and tragic, it is very interesting; the eyes are alive." Then the writer made a statement that bares the influence that Stieglitz had on him: "I shall have to modify my piece which is to accompany it a bit in accordance, for the piece was too blithe."[12] Indeed the portrait of Rosenfeld in Authors Today and Yesterday is "earnest and unsmiling and tragic," and the blithe tone of the piece, even after modification, is typified by this passage: "Matriculated with breathless expectation at Yale, in the class of 1912, he [Rosenfeld] continued uneducable, and contributed spasmodically to the 'Lit.' Eventually he became an editor of the magazine, but not the chairman of the editorial board."

What Rosenfeld seemed not to grasp is the fact that most portraits by Stieglitz, even those of children, are quite somber. And for very good reason: his portraiture conveys not an impression of a particular personality nor even the essence of character but rather a special vision of the spirit of humanity, of "life"-- a vision in which the elements of tragedy and pathos predominate. Portraits by Stieglitz seem to utter a voiceless cry: "I suffer."[13] So many of them have a fixed stare that Waldo Frank once suggested, only half in jest, that Stieglitz hypnotized his sitters. But the "heartache," as Stieglitz called it, that is unveiled in the photographs is counterbalanced by an inner strength that answers, "I shall endure and even prevail, because I am human and alive."

Though unquestionably a master of portraiture, Stieglitz was not the appropriate photographer to illustrate an entry in a conventional volume of biographical reference. His images, individually and collectively, reveal not men but mankind. This is another way of

saying that he was an artist of the ideal, not a mere
documentarian of the actual. His portraits suggest not
so much the individual differences as the empathic kin-
ship of the human species. For Stieglitz as for Poe,
we are all players in the tragedy called Man.

The worst effect of Stieglitz's influence on Rosen-
feld, some observers have said, was that it limited the
young critic's very orbit. A few years after Rosenfeld's
death, Van Wyck Brooks commented on the narrow horizon
of the man with whom he helped found the Seven Arts and
coedit for a time the American Caravan: "In painting
Paul scarcely strayed beyond the borders of Stieglitz's
group.--he could not in his heart believe in a painter
who did not have the Stieglitz imprimatur."[14]

Rosenfeld too was aware that his reach was limited,
but to him this represented concentration rather than
restriction, and he thought, somewhat mistakenly, that
his boundaries were those of America, not those of any
group. After agreeing,in one of his letters to Stieg-
litz, that his exclusive interest in Americans was
"significant," Rosenfeld went on to explain: "My guess
is that something happened because of the presence
around me of certain people. Something has interplayed,
back and forth in my consciousness."[15] The "certain
people" were chiefly those of the Stieglitz circle, and
the interplay materialized, two years later, as Port of
New York: Essays on Fourteen American Moderns (1924).

In telling Stieglitz about the essays he intended
to collect in Port of New York, Rosenfeld mentioned
their national unity: "Nearly all the pieces I care to
reproduce are about Americans."[16] And in the foreword
to the book itself he spoke of the common denominator
as "a new spirit dawning in American life." But a
glance over the fourteen profiles reveals that ten of
these Americans were also Stieglitzians. And indeed
later, in his autobiographical sketch in Authors Today
and Yesterday (1933), Rosenfeld defined them as "a
group of fourteen artists that found a center in the
New York studio of the photographer Alfred Stieglitz."
Included were painters Marsden Hartley, John Marin,
Arthur Dove,and Georgia O'Keeffe (all protégés at one
time or another of Stieglitz); writers Sherwood Ander-
son, William Carlos Williams, and Carl Sandburg (the

last, a friend if not a follower of Stieglitz); critics Randolph Bourne and Van Wyck Brooks (whose "radicalism" found an affinity with Stieglitz); and educator Margaret Naumburg (who received the Stieglitzian spirit through her husband, Waldo Frank).[17]

Referring again to his conspicuous partiality, Rosenfeld speculated that perhaps he was involved in a "general something," as he put it to Stieglitz, "on which I as well as others have floated."[18] This current (rather than, as some have said, the author's "relatedness") supplies the real unity of Port of New York, a unity broken only by the studies of Kenneth Miller and Roger Sessions. Except for these, Rosenfeld's company of "American moderns" all represented the stream of organic vitalism flowing through the nation's arts during the first quarter of the twentieth century, a tradition that Rosenfeld presents as beginning with Albert Pinkham Ryder and climaxing in Alfred Stieglitz, whose essay concludes the volume.

What Rosenfeld saw himself involved in, then, was not the little soul of a cult, as implied by Van Wyck Brooks, but rather the very Zeitgeist of the first quarter of this century. And he was partly right, in that he was indeed being carried along on one branch of the contemporary cultural stream; the "general something" that he sensed was in fact a tide of lyrical expressionism in the arts based on a recovered philosophical idealism. What he failed to recognize, dazed as he was by Stieglitz, was the countercurrent of objective realism which was coursing through the Twenties and which by the end of the decade would carry Sinclair Lewis to Stockholm.

Naturally enough, it was Rosenfeld's studies of Stieglitz and his circle that the photographer was most anxious to read, and Rosenfeld dutifully submitted the manuscripts to him. "I am eager to hear what you have to say of the [essay on John] Marin," Rosenfeld prodded Stieglitz as he began to assemble the profiles for Port of New York.[19] Stieglitz's observations were sometimes so cogent that Rosenfeld spliced them directly into his own compositions. "Somehow everything which you said about [Arthur] Dove," Rosenfeld admitted to his mentor,

"seemed to corroborate some feeling of my own, so that I have made so bold as to lift a few phrases out of your last note about him and use them in my paper."[20]

Despite his own pursuit for perfection, in which he would make scores of prints from a single negative before selecting the best, Stieglitz recognized that Rosenfeld's love for the long labor of the file, combined with his natural diffidence, dragged out the act of writing. And so when Rosenfeld mentioned that he might revise the essay on Marsden Hartley before including it in _Port of New York_, Stieglitz replied with uncommon vehemence:

> As for the Hartley essay, I don't think you should touch it.--In spite of some points you would like to rewrite--that would mean rewriting nearly--or really--all of it. And I feel that what you might gain in one way, you'd lose in another. First of all Hartley was satisfied. Secondly, & of more importance, I feel that what you wrote had a particular freshness to it which is different from anything you might write now--a _different_ freshness. And I feel the book will gain thereby. . . . If you become supercritical, you'll never get through.[21]

One motive for finishing _Port of New York_ was to redress the insult implied by Harold Stearns' _Civilization in the United States_ (1922). This influential symposium on American culture had studiously skirted all mention of the Stieglitz group, and hence it was up to Rosenfeld to even the balance. "Now you know," Stieglitz urged his laggard champion, "that I am the last one to advise you not to be critical of your work-- more so now than ever--but I do feel it is important to _you_ & _all_ of us interested to have _that_ book out on time." [22]

Though motivated by group interest, Stieglitz's exhortation ironically had the side effect of thwarting Rosenfeld's intention to soften his evaluation of one of the group. Stieglitz knew quite well that the

47

critic had come to regard Hartley's faults less damning than he had earlier thought. The revised essay undoubtedly would have presented the painter in a kinder light. As it stands in Port of New York, however, the critique is mainly adverse, stating that few of Hartley's paintings are "completely developed organisms," that the artist "has not immersed himself sufficiently deeply in his material," and that his bravura style allies him with other "peacocks in the ranks of American paint." Had William Carlos Williams known of this incident, he probably would have taken it as further evidence of Stieglitz's mistreatment of Hartley.

Like Emerson before him, Stieglitz was not one to tremble before the "hobgoblin of a foolish consistency." At one point he would tell Rosenfeld not to change a word; at other times he would suggest or even demand specific alterations. When Rosenfeld said that he was worried about the "muzziness," the "impressionism," and the interrupted flow of the Stieglitz chapter in Port of New York, the photographer replied, "If you feel you are clear, why, let it stand.--I wouldn't change anything I felt was expressive nor add a word I didn't feel."[23]

But Stieglitz's attitude was somewhat different when Rosenfeld sent him the manuscript of the chapter "for the purpose of getting [his] criticism, in the hopes that [his] suggestions [would] do as much for this piece as they did for the one on O'Keeffe."[24] In his response Stieglitz led off by objecting to the title that Rosenfeld had conferred on him; he asked the author to change the phrase "greatest artist in America" because it was an "unnecessary challenge." Not mentioning his lifelong distaste for labels, he explained, "It's the competitive idea & superlative claim that are questionable if true."[25]

Again like Emerson, Stieglitz shunned the superlative because he rejected the idea of hierarchies of human endeavor. A work of art was good to the degree that it was "true work" as measured by the artist's own standards. Professional rivalry and petty factionalism had been traits of the salon expositions from which Stieglitz had "seceded" back in 1902. Competition would destroy the communal spirit that Stieglitz strove to

"seemed to corroborate some feeling of my own, so that I have made so bold as to lift a few phrases out of your last note about him and use them in my paper."20

Despite his own pursuit for perfection, in which he would make scores of prints from a single negative before selecting the best, Stieglitz recognized that Rosenfeld's love for the long labor of the file, combined with his natural diffidence, dragged out the act of writing. And so when Rosenfeld mentioned that he might revise the essay on Marsden Hartley before including it in Port of New York, Stieglitz replied with uncommon vehemence:

> As for the Hartley essay, I don't think you should touch it.--In spite of some points you would like to rewrite--that would mean rewriting nearly--or really--all of it. And I feel that what you might gain in one way, you'd lose in another. First of all Hartley was satisfied. Secondly, & of more importance, I feel that what you wrote had a particular freshness to it which is different from anything you might write now--a different freshness. And I feel the book will gain thereby. . . . If you become supercritical, you'll never get through.21

One motive for finishing Port of New York was to redress the insult implied by Harold Stearns' Civilization in the United States (1922). This influential symposium on American culture had studiously skirted all mention of the Stieglitz group, and hence it was up to Rosenfeld to even the balance. "Now you know," Stieglitz urged his laggard champion, "that I am the last one to advise you not to be critical of your work-- more so now than ever--but I do feel it is important to you & all of us interested to have that book out on time." 22

Though motivated by group interest, Stieglitz's exhortation ironically had the side effect of thwarting Rosenfeld's intention to soften his evaluation of one of the group. Stieglitz knew quite well that the

47

critic had come to regard Hartley's faults less damning than he had earlier thought. The revised essay undoubtedly would have presented the painter in a kinder light. As it stands in Port of New York, however, the critique is mainly adverse, stating that few of Hartley's paintings are "completely developed organisms," that the artist "has not immersed himself sufficiently deeply in his material," and that his bravura style allies him with other "peacocks in the ranks of American paint." Had William Carlos Williams known of this incident, he probably would have taken it as further evidence of Stieglitz's mistreatment of Hartley.

Like Emerson before him, Stieglitz was not one to tremble before the "hobgoblin of a foolish consistency." At one point he would tell Rosenfeld not to change a word; at other times he would suggest or even demand specific alterations. When Rosenfeld said that he was worried about the "muzziness," the "impressionism," and the interrupted flow of the Stieglitz chapter in Port of New York, the photographer replied, "If you feel you are clear, why, let it stand.--I wouldn't change anything I _felt_ was expressive nor add a word I didn't feel."[23]

But Stieglitz's attitude was somewhat different when Rosenfeld sent him the manuscript of the chapter "for the purpose of getting [his] criticism, in the hopes that [his] suggestions [would] do as much for this piece as they did for the one on O'Keeffe."[24] In his response Stieglitz led off by objecting to the title that Rosenfeld had conferred on him; he asked the author to change the phrase "greatest artist in America" because it was an "unnecessary challenge." Not mentioning his lifelong distaste for labels, he explained, "It's the competitive idea & superlative claim that are questionable if true."[25]

Again like Emerson, Stieglitz shunned the superlative because he rejected the idea of hierarchies of human endeavor. A work of art was good to the degree that it was "true work" as measured by the artist's own standards. Professional rivalry and petty factionalism had been traits of the salon expositions from which Stieglitz had "seceded" back in 1902. Competition would destroy the communal spirit that Stieglitz strove to

instill among his followers; competition was the motive of hated commerce. The artist, Stieglitz held, is above all an individualist, competing only against himself.

As more and more suggestions about the essay poured in from Stieglitz, Rosenfeld struggled to remain good-natured, but eventually the strain began to show. At one point the author stated, rather hollowly, that he anticipated making "many corrections all around of the sort" that Stieglitz had suggested.[26] But some weeks later, after thanking the photographer for additional suggestions, Rosenfeld sighed, "I have already organized them or tried to organize them, into the body of the paper. I hope it will retain some vestige of the outline which it had; it is so crusted over with additions."[27]

Despite all the revisions, Stieglitz was still not pleased with the final draft of Port of New York and concluded, "In parts it isn't closely enough knit for my taste."[28] Rosenfeld did, in truth, fail to unify all the elements of his book. Some of the figures (notably Kenneth Miller and Roger Sessions) had no essential connection with the others, and the author misconstrued the manner in which the avant-garde movement had ramified in America.[29] Rosenfeld thought that Port of New York presented a "picture of a number of individualities moving through several gateways to a common point."[30] And that common point in Rosenfeld's cartography was marked "291," as the writer and others called Stieglitz. But despite Rosenfeld's passion to discover a "single identity" and a "single tendency" in our cultural environment, Port of New York reveals only the diversity of the arts in twentieth-century America. Stieglitz was many things great and good, but he was no Virgin of Chartres. His "Invisible Star" attracted mainly the lyrical expressionists, and Western man has for centuries been moving from unity to multiplicity, as Rosenfeld should have remembered from his other idol, Henry Adams.

Stieglitz's corrective criticism of Port of New York seems almost casual compared to his editing of "The Boy in the Dark Room," Rosenfeld's description of the photographer's early career for the "collective portrait" called America and Alfred Stieglitz (1934).[31]

By the time Rosenfeld began writing this piece, Stieglitz was associated with Dorothy Norman, a lady who had dedicated herself to preserving the Stieglitz legend and who become one of the guiding forces in preparing the festschrift just mentioned.[32] With Mrs. Norman's help, then, Stieglitz set about editing the manuscript of "The Boy in the Dark Room." It was not a cursory process. In one letter alone Rosenfeld responded to five different challenges, ranging from such philosophical problems as the nature of "cosmic consciousness" and the relation of God to matter, down to the question of capitalizing the word artist.[33]

Rosenfeld finally protested when the editing went on and on, but even his remonstrance was apologetic: he regretted that "so many changes [had] been necessary" because of "more or less inevitable errors." But compliance did not come easily in one instance. Rosenfeld had used the word courser in an anecdote about Stieglitz's childhood steeplechase game, and such a word, contested Stieglitz, would never have occurred to an adolescent. Rosenfeld agreed reluctantly to change the word to racer, but he reminded Stieglitz that the story's point of view was not that of the boy but rather that of the narrator, to whom the word was not esoteric. He added, "The word courser made an agreeable variant to the word racehorse, which I had used several times."[34] But Stieglitz's long acquaintance with the track and the racing journals had ingrained his sense of track talk, and he refused to give up. The word courser, he insisted, was simply out of place. Rosenfeld finally had to agree that in "equine circles" the term was not synonymous with racehorse, but he denied that the problem stemmed from "literary indulgence" as Stieglitz claimed.[35]

Dorothy Norman's revisions of "The Boy in the Dark Room" were even more extensive than Stieglitz's, at times amounting to what Rosenfeld called "operations." Yet the author yielded to almost every suggestion and gracefully conceded that the changes had resulted in a "clarification of ideas." In the end "The Boy in the Dark Room" somehow managed to retain its integrity, and it became, and remains, one of the most readable and informative chapters of America and Alfred Stieglitz.

[1] Waldo Frank to AS, July 31, 1923. Frank's italics.

[2] AS to Waldo Frank, March 6, 1927.

[3] Waldo Frank to AS, March 23, 1927.

[4] For Stieglitz's account of how he first acquired Georgia O'Keeffe's drawings for his 291 gallery, see Seligmann, _AS Talking_, pp. 23, 70.

[5] AS to Waldo Frank, April 4, 1927.

[6] Ibid.

[7] Waldo Frank to AS, Feb. 25, 1922.

[8] AS to Waldo Frank, Feb. 25, 1922.

[9] Walker Gilmer, _Horace Liveright: Publisher of the Twenties_ (New York: David Lewis, 1970), pp. 242-43.

[10] Paul Rosenfeld to AS, Aug. 30, 1920. Rosenfeld's italics.

[11] In his letter to Stieglitz on August 24, 1933, Rosenfeld referred to this book as _Living Authors_, but in actuality his sketch together with Stieglitz's portrait appeared in _Authors Today and Yesterday: A Companion Volume to Living Authors_, ed. Stanley J. Kunitz, Howard Haycraft, and W. C. Hadden (New York: H. W. Wilson, 1933), pp. 584-87.

[12] Paul Rosenfeld to AS, Aug. 4, 1933.

13 In contrast to this "tragic" portrait of Rosen-feld, the photograph, also by Stieglitz, that the critic sent to Sherwood Anderson to hang at Ripshin Farm shows a rotund, shyly smiling pipe smoker, an image I person-ally find more consonant with the temperament reflected in Rosenfeld's writings. Other exceptions to the usual seriousness of Stieglitz's work are the laughing Ital-ian villagers in A Good Joke (1887) and the merry child (probably Stieglitz's daughter, Katherine) in The Swimming Lesson (1906). Dorothy Norman cautioned me that Stieglitz made laughing pictures of her, too. As for the typically somber quality of Stieglitz's portraits, Mrs. Norman believes that my general conclu-sion is correct.

14 Van Wyck Brooks, An Autobiography (New York: Dutton, 1965), p. 262.

15 Paul Rosenfeld to AS, Sept. 30, [1922].

16 Paul Rosenfeld to AS, [Oct. 1922].

17 Rosenfeld surely planned to include an essay on Waldo Frank in Port of New York, but, for whatever reason, it did not materialize until Men Seen was published in 1925.

18 Paul Rosenfeld to AS, [Oct. 1922].

19 Paul Rosenfeld to AS, July 23, [1923].

20 Paul Rosenfeld to AS, Aug. 5, [1923]. Stieglitz's note has disappeared; until it turns up, identification of the borrowed phrases is impossible.

21 AS to Paul Rosenfeld, July 10, 1923.

22 Ibid.

23 AS to Paul Rosenfeld, Nov. 17, 1923.

[24] Paul Rosenfeld to AS, Nov. 8, [1923].

[25] AS to Paul Rosenfeld, Nov. 14, 1923.

[26] Paul Rosenfeld to AS, [? Nov. 15, 1923].

[27] Paul Rosenfeld to AS, [Nov. 23, 1923].

[28] AS to Paul Rosenfeld, July 12, 1924.

[29] For a thorough description of this movement, see William Innes Homer, Alfred Stieglitz and the American Avant-Garde (Boston: Little, Brown, 1977).

[30] Paul Rosenfeld, Men Seen: Twenty-four Modern Authors (1925; rpt. New York: Books for Libraries, 1967), p. v. Rosenfeld made no attempt to unify this book; he termed it simply a "miscellany."

[31] Waldo Frank et al., eds., America and Alfred Stieglitz: A Collective Portrait (Garden City, N.Y.: Doubleday, Doran, 1934); hereafter cited as Frank, America & AS.

[32] From 1938 to 1945 Dorothy Norman edited and published Twice a Year, a liberal journal of the arts in which she printed various statements by and reminiscences of Stieglitz. See my bibliography for dates and page numbers.

[33] Paul Rosenfeld to AS, July 6, 1934. Stieglitz's letters concerning the editing of "The Boy in the Dark Room" may have been lost; they are not among his papers in the Beinecke Rare Book and Manuscript Library. The title of the essay is both a pun on the word darkroom and an echo of Rosenfeld's 1928 autobiographical novel, The Boy in the Sun, whose title in turn alludes to that of D. H. Lawrence's collaborative The Boy in the Bush (1924).

34 Paul Rosenfeld to AS, Aug. 1, 1934. Edward
Dahlberg also recalls Stieglitz's saying that "when
Rosenfeld was writing one of his immaculate essays,
'Deliberations,' he did not know what to do with the
word horse. . . . He had used stallion, charger,
courser, but now he was at the end of his resources"
(The Confessions of Edward Dahlberg [New York: George
Braziller, 1971], p. 244; italics added). Rosenfeld's
perplexity also repeats Dawson Fairchild's agonized
search for synonyms for horse in Faulkner's Mosquitoes
(1927). Fairchild is of course a caricature of Sher-
wood Anderson, not Paul Rosenfeld.

35 Paul Rosenfeld to AS, Aug. 5, 1934.

CHAPTER 4

ESSENCE OF LEADERSHIP

There remains yet another role within the active side of Stieglitz's career that warrants attention before we turn to his influence as a symbol, and that is the part he played as a leader in the world of American art. This role was the most public vector of his force and extended through his adult lifetime. It was perhaps the common denominator of his manifold activities.

The mantle of leadership fell early upon Stieglitz, as sometimes happens when a person sights his "Invisible Star" before other lights have lured him off course. In the 1890's, while still in his twenties but already a renowned master photographer, Stieglitz rallied a group of kindred spirits around him and spearheaded the movement known as Pictorial Photography. The goal of the Pictorialists was to revitalize photography and thereby win universal recognition that the products of the camera could be as "artistic" as those of the brush and the pen.[1]

Anyone who has seen a cross section of the daguerreotypes and the wet plates of 1840-1880, knows quite well that even in the infancy of photography there were practitioners whose motives and products were artistic in every sense of the word. But a few years after Stieglitz entered the field, the ease and convenience of pushing a button and letting Kodak do the rest spawned hordes of Sunday snapshooters. In the public mind photography became just another fad, like the bicycling craze of the time. Such was the debased standing of amateur photography that the Pictorial Photographers united to redress. For a time the movement was headquartered in the Camera Club of New York, but Stieglitz's outspoken campaign against dilettantism offended certain members, and he eventually resigned his positions as vice president and as editor of Camera Notes, the club's journal.

To foster excellence by publishing truly creative achievements in photography, Stieglitz inaugurated his

peerless Camera Work quarterly in 1903 and two years
later opened the Little Galleries of the Photo-Secession
at 291 Fifth Avenue. Thereupon his leadership entered
its major phase. At 291, as the galleries were soon
called by one and all, Stieglitz continued his fight for
photography as an art, but he extended his influence in
new directions: he introduced modern European art in
this country and simultaneously began to foster deserv-
ing American talent in both photography and painting.
He realized that gifted American artists were being
ignored both by the philistine public and, because of
what Randolph Bourne called "our cultural humility,"
by Europhile art collectors and gallery owners. But
Stieglitz was no ranting American chauvinist. For him
art transcended nationality, and if he gave special
attention to Americans, it was because from his vantage
point he could see his countrymen's worth as well as
their neglect, but most of all because he shared the
mystic faith in America of Emerson and Whitman.

Stieglitz's identity as champion had been estab-
lished for two decades when Waldo Frank set himself the
task of defining our culture, and so it was no accident
that in Our America (1919) and The Re-discovery of
America (1929) he chose to spotlight Stieglitz as pre-
eminently a leader. In the earlier of these two
cultural vivisections, Frank begins by exposing the
consequences, as he sees them, of the Puritans' asceti-
cism. Then, after bowing to a handful of New Englanders
who have rebelled against the Puritan "nay-saying,"
the critic turns his attention to New York. The nervous
tension of this metropolis, despite its more hideous
manifestations, suggests to Frank that "here, if any-
where, you must look for the leader and the critic."[2]
Frank does not have to look far. The man in whom the
"creative meanings of these words [leader and critic]
meet," he announces, is Stieglitz. Here is the "Apostle
of self-liberation in a destructive land" and the leader
of the "cause of life for life's sake, the cause of self-
expression."[3]

Thus far Frank's interpretation of Stieglitz
follows familiar lines, but before Frank moves on to
other New York leaders in Our America, his thinking
takes a singular tack. Despite the fact that Stieglitz

was, if anything, a Romantic pantheist and worshiped Goethe's _Erdgeist_ rather than Yahweh, Frank proclaims: "Stieglitz is primarily the Jewish mystic. Suffering is his daily bread: sacrifice is his creed: failure is his beloved."[4]

A certain amount of truth underlies Frank's statement. Stieglitz's experience was indeed keyed to suffering, sacrifice, and failure. But in locating Stieglitz in the Jewish mystical tradition, Frank was erroneously projecting his own _idée fixe_ at the time he was writing _Our America_. Gorham Munson, one of Frank's closest associates, explains his friend's preoccupation between 1917 and 1922: "He discovered the Jewish prophets in the Bible. . . . Something came into his work that was not originally present, and this unpredictable element changed his forms, exalted his attitude, and transformed his materials."[5] This unpredictable element undoubtedly led Frank subjectively to transform Stieglitz into a Jewish mystic. The photographer himself nowhere stressed his Jewishness. In his own mind he saw himself as a typical American, and whenever he admitted the influence of another culture, it was likely to be German rather than Jewish.

But Frank's ethnic enthusiasm did at one point prompt Stieglitz to reflect on his own character. "I never much thought of myself as a Jew or any other particular thing," he wrote to Frank, "but I'm beginning to feel that it must be _the Jew_ in me that is after all the key to my impossible makeup."[6] Such speculation, however, had little lasting interest for Stieglitz, and he immediately proceeded to define himself in completely different terms: "But Jew or no Jew--I know life is terribly hard--particularly for those who believe in its wonder--& who can't believe that Ugliness will survive at the expense of Truth-- Beauty--Light."[7] For Stieglitz, then, suffering, sacrifice, and failure were not so much the traits of the Jewish mystic as they were the taxes levied by the philistines on the artist-idealist.

Among Stieglitz's other literary associates the only one who seemed particularly conscious of the photographer's "Jewish blood" was Sherwood Anderson,

although Paul Rosenfeld once intimated that Stieglitz's dream of a community of artists at 291 Fifth Avenue was based on "strong Jewish family feeling."[8] Near the end of A Story Teller's Story, Anderson mulls over the "odd" fact that so many of his friends and mentors--Stieglitz, Frank, Rosenfeld, and others--are Jews. He speculates that this affinity might be somehow connected with the Jews' "secret sense of separateness from life about them."[9] Perhaps they recognize him as a fellow isolato: "The man of Jewish blood, in an American city, could at any rate feel no more separateness from life about him than the advertising writer in a Chicago advertising agency who had within him a love of the craft of words."[10]

Though Anderson did not make the specific connection, he would have been quite right in attributing this sense of separateness to Stieglitz, but not because he was a Jew. From the day his family persuaded him to give up the congenial German student's life of the 1880's and return to his responsibilities in what seemed to him the inhuman city of New York, Stieglitz complained of a feeling of "rootlessness." Eventually he came to believe, as did Anderson, that alienation is the particular fate of Americans and that such feelings were the mark therefore of the representative citizen of this land, a role that both men coveted and to a remarkable degree fulfilled.

In another context the storyteller continued his musings on Stieglitz's Jewishness. Anderson was no bigot, but the best he could do in avoiding the all-inclusive stereotype of "the Jew" was to divide his friends in effect into "good Jews" and "bad Jews." Thus he drew a simple line between the "very fine" Jews such as Stieglitz and those like Waldo Frank who had "something of the Jewish prophet spirit in them, preachers really and by just that much corrupt."[11] We have already looked at Frank's fatidic period; what is notable here is that the creator of Winesburg, Ohio apparently preferred Jews who were not too blatant about it. In his fiction, despite his wide acquaintance with Jews, Anderson never progressed beyond the early pasteboard figure of "Lewis, the Jew" in Windy McPherson's Son (1916), whose sole trait is "ability in driving sharp bargains."[12]

During the 1903-1917 era of Camera Work and 291,
Stieglitz was recognized not only as the leader of the
Pictorial Photography movement and its successor, the
Photo-Secession, but also as the first American patron
of modern painting. The latter recognition came as a
result of his introducing Rodin, Matisse, Toulouse-
Lautrec, Henri Rousseau, Cezanne, and Picasso to these
shores years before the celebrated Armory Show of 1913
followed suit. In this role of herald of avant-garde
art, Stieglitz also performed one of his most momentous
literary acts: the premiere publication of Gertrude
Stein. As Stieglitz recalled the event, it happened
this way.[13]

In late 1911 or early 1912 a stranger turned up at
291 with a "bulging portfolio" of unpublished manu-
scripts. Stieglitz explained to her that he was not
a publisher in the usual sense, although he did produce
Camera Work. The woman, who still had not said that
she represented someone else, replied that she knew
about his introducing Matisse and Picasso, and urged
him to read two manuscripts concerning these artists.
After reading thirty or forty words of each, Stieglitz
announced, "I don't know the meaning of all this. But
it sounds good to me. I think I can use both manu-
scripts."[14]

Stieglitz went on to say that he intended to devote
an entire issue of Camera Work to the evolution of
Matisse and Picasso, and that he was presently looking
for appropriate literary matter to accompany the pic-
tures. The unconventional prose of the manuscripts was
no impediment for one who habitually followed his
intuitions, and Stieglitz came to an immediate decision.
"Somehow or other these manuscripts, even though I
don't understand them, seem to fit into the volume [of
Camera Work] I have in mind," he told the agent.[15]
Here as elsewhere Stieglitz sidestepped the pitfall of
trying to understand art that had cut loose from the
tether of realistic representation and logical struc-
ture. He was able to sense the rightness of what Stein
was doing in the same way he was able to see the signif-
icance of Matisse and Picasso.

After Stieglitz accepted the manuscripts, the
emissary identified the author as Gertrude Stein

and herself as Mrs. Edward Knoblock (wife of the play-wright). She reminded Stieglitz that he had met the author at brother Leo Stein's Paris studio in 1909, but he barely remembered the woman with, as he put it, the "semi-Mona Lisa smile."[16] And so it was not for old times' sake that he published Stein's word portraits of Matisse and Picasso in the special number of Camera Work that featured the two painters. This debut in August of 1912 was the basis for her later tribute to Stieglitz: "He was the first one that ever printed anything that I had done. / And you can imagine what that meant to me or to any one."[17]

The editorial that prefaced the special Matisse-Picasso number of Camera Work contains the curious statement that the Stein "articles themselves, rather than the subjects they deal with or the illustrations that accompany them, are the true raison d'être of this issue of Camera Work."[18] But Stieglitz, remember, told Stein's emissary that the issue had been planned before the manuscripts arrived. Thus the editorial's emphasis on the articles seems strangely contradictory. (The same statement appeared in an advertisement concerning the special issue.)

The only explanation I can offer is that perhaps someone other than Stieglitz wrote the editorial. Its rhetorical flourishes and the presence of a French idiom are not at all characteristic of Stieglitz's prose style, and a later reference in the editorial to literary criticism suggests that the actual writer may have been J. B. Kerfoot, the literary critic of the old Life magazine and a man quite active in editing Camera Work. Furthermore, the vocabulary of a journalist would likely include the term tyro, which appears in the editorial shortly after raison d'être. Stieglitz shunned clichés and jargon; like Sherwood Anderson, he detested "smartness" in writing.

But such an explanation is only partly satisfactory, because, even if Stieglitz did not himself compose the editorial, he would not have published it unless he approved the contents. And we know from his criticism of Waldo Frank that he insisted on seeing a job "all the way through." Perhaps the answer lies in Stieglitz's later admission that he wanted to shock the literary crowd with Stein's word portraits in the

same way he had earlier shaken the artistic Establish-
ment with the modernistic works he exhibited at 291.
The editorial, by stressing that Stein, Matisse, and
Picasso were all part of the avant-garde movement and
thus subject to similar misunderstanding and ridicule,
reflects the spirit of Stieglitz's motivation, if not
his priorities, in publishing Stein.

At the time that Stieglitz accepted Stein's word
portraits (payment being one hundred copies of the
issue of Camera Work in which they appeared), he
declined the other manuscripts tendered by the author's
go-between, saying that after Camera Work's special
number was circulated, Stein would have no trouble
finding publishers for her other things.[19] She indeed
found a publisher for Tender Buttons in 1914, but in
the interim some pieces by or about Stein did in fact
materialize in Stieglitz's journal. He published her
"Portrait of Mabel Dodge at the Villa Curonia" in June
of 1913, and exactly one year later he reprinted the
Stein piece that had formed part of the introduction
to a Marsden Hartley exhibition at 291. Also, in
October of 1912 Camera Work reprinted, from the New
York Globe, Hutchins Hapgood's salute to Three Lives
and the Matisse-Picasso essays as a "new form of lit-
erature," one that "gives us the sense of the mysteries
of our inner lives."[20]

In view of Stein's early encounter with Camera
Work, one is tempted to look for the influence of
photography on her prose. Noticing her "blatant"
attempts to "emulate the methods of painting," critics
have thoroughly explored the impact of cubism on
Stein's writing.[21] But photography has been generally
neglected, despite the fact that in at least two places
the author herself compared the repetitive technique of
her prose to the sequence of images on a piece of
motion picture film. Each film image is slightly dif-
ferent from the others, but together they make a unified
impression on the retina and on the mind. Similarly,
according to Stein, a "continuous succession of the
statement" results in "not many things but one thing."[22]
But because she wrote in this manner long before she had
seen a "cinema," she concluded that the similarity to
film was merely an odd coincidence, or at most the

effect of living in the "period of the cinema and series production."[23] Repetition as an artistic device also recalls the cubists' use of multiple images, best known in Marcel Duchamp's Nude Descending a Staircase, No. 11 (1912). But Stein herself attributed her repetitive style to her habit of "carefully listening to all the people telling their story." Such narratives, she noticed, varied somewhat each time they were told, resulting in freshness and immediacy. These qualities she sought to embody in her word portraits by a similar method of repetition with variation.[24]

Stein's fallacy lies in her confusion of three distinct types of experience: the visual image, the spoken word, and the written word. Her motion picture analogy is groundless because the individual frames of the film do not exist a parte subjecti. The spectator is conscious only of the composite image; the actual substance of the image is not unimportant, but its interest is technical and clinical, rather than aesthetic. When one reads a series of statements, however, the result is not a composite image but an expanded concept. Words per se are not images, and language is not exclusively or even mainly visual. The limitations of strictly imagistic poetry testify to the truth of this observation.

More crucial was Stein's disregard for the differences between the spoken and the written word. Noting a phenomenon of oral communication, she mistakenly tried to use it in the written mode. As a result her word portraits must be scanned rapidly enough to emphasize the similarity between individual statements but slowly enough to reveal the variation, and all the while the reader's mind must remain virtually passive, always attending to sound rather than meaning. The demand is too much for ordinary readers; most of them come away bored--or dizzied--by Stein's repetition with variation. Young Ernest Hemingway picked up this device, and others, from Stein; but he was wise enough to use it, in most instances, with moderation.

Stein simply failed to remember that readers are just that, and not an audience in the root sense of the word. You have only to listen to a recording of a piece

by Stein to realize that it is much more enjoyable in aural form than on the printed page. I suppose all this merely repeats an old lesson from the oral tradition in literature: in a recitation an audience will tolerate or even require a certain amount of repetition. But an equal quantity of repetition in print is offensive.

Among the myriad analyses of Stein's innovative prose style, no one seems to have noticed that the theory of repetition had received a good deal of attention in the early issues of Camera Work years before the author of "a rose is a rose is a rose" made this technique her trademark. In the very first number (January 1903) of Stieglitz's quarterly, Sadakichi Hartmann, writing under the pseudonym of Sidney Allan, explored the device of "Repetition, with Slight Variation" and found it a characteristic of Japanese art, occurring also in the refrains of ballads, in Poe's poems, in the French Symbolists, and, above all, in the work of Maurice Maeterlinck.[25]

In the next issue of the journal, Dallett Fuguet took up this idea and applied it specifically to photography, urging the "man behind the camera" to "attempt repetition with variation, even in composition."[26] Whether Stein actually read these articles is a matter for future investigation, but her emissary, Mrs. Knoblock, was apparently familiar with Camera Work. She had told Stieglitz that she was offering him the manuscripts because she knew that he had been "instrumental in introducing Matisse to America as well as Picasso."[27] Picasso had appeared in Camera Work only a couple of months before she offered Stieglitz the Stein manuscripts; Matisse had been featured a year earlier.

The principle of repetition with variation had been explored, and evidently abandoned, in the pages of Camera Work years before the writing (1906-09) of The Making of Americans and the initial publication of Three Lives in 1909. Future assessments of Stein's originality are obliged to take into account this anticipation of one of her key theories.

NOTES

CHAPTER 4

[1] Stieglitz describes the methods and the objectives of the pictorial movement in two articles of his own authorship: "Pictorial Photography," Scribner's, Nov. 1899, pp. 528-37; and "Modern Pictorial Photography," Century, Oct. 1902, pp. 822-26.

[2] Waldo Frank, Our America (New York: Boni & Liveright, 1919), p. 180.

[3] Ibid., pp. 180, 186.

[4] Ibid., p. 186. Frank also names Stieglitz as one of the "real leaders of Jewry" in his essay "With Marx, Spinoza . . . " (reprinted in his In the American Jungle [1937; rpt. Freeport, N.Y.: Books for Libraries, 1968], p. 245).

[5] Munson, Destinations, pp. 101-02.

[6] AS to Waldo Frank, April 3, 1925.

[7] Ibid.

[8] Rosenfeld, Port of New York, p. 264.

[9] Anderson, A Story Teller's Story, p. 395.

[10] Ibid., p. 396.

[11] Sherwood Anderson to Roger Sergel, [Dec. 18, 1923]; in Letters of SA, p. 117.

[12] Sherwood Anderson, Windy McPherson's Son (1916; rpt. Chicago: Univ. of Chicago Press, 1965), p. 222.

[13] Alfred Stieglitz, "_Camera Work_ Introduces Gertrude Stein to America," _Twice a Year_, nos. 14-15 (Fall-Winter, Spring-Summer 1946-47), pp. 192-95.

[14] Ibid., p. 193.

[15] Ibid., p. 194.

[16] According to Katherine Anne Porter, Stieglitz's volubility "got the drop" on Stein during their first meeting ("Gertrude Stein: A Self-Portrait," _Harper's_, Dec. 1947, pp. 519-28).

[17] Frank, _America & AS_, p. 280. Stein apparently discounted the priority of _Three Lives_, which was published in 1909 by the Grafton Press but at her own expense.

[18] Editorial, _Camera Work_, special number (Aug. 1912), p. 3.

[19] Alfred Stieglitz, "_Camera Work_ Introduces Gertrude Stein to America," _Twice a Year_, nos. 14-15 (Fall-Winter, Spring-Summer 1946-47), p. 194.

[20] Stieglitz told Dorothy Norman that he himself wrote the statement about Stein that appears in Hapgood's column. (From my interview with Mrs. Norman).

[21] Two major studies in this vein are John M. Brinnin, _The Third Rose: Gertrude Stein and Her World_ (Boston: Little, Brown, 1959); and Michael J. Hoffman, _The Development of Abstractionism in the Writings of Gertrude Stein_ (Philadelphia: Univ. of Pennsylvania Press, 1965). For an interpretation of Stein's word portraits as "cubist prose paintings," see Michael J. Hoffman, "Gertrude Stein's 'Portraits,'" _Twentieth Century Literature_, 2 (Oct. 1965), 115-22.

22 Gertrude Stein, "Portraits and Repetition,"
in her _Lectures in America_ (1935; rpt. Boston: Beacon
Press, 1957), pp. 176-77.

23 Ibid.

24 Gertrude Stein, "How Writing Is Written,"
Choate Literary Magazine, Feb. 1935, pp. 5-14.

25 Sidney Allan [Sadakichi Hartmann], "Repetition,
with Slight Variation," _Camera Work_, no. 1 (Jan. 1903),
pp. 30-34.

26 Dallett Fuguet, "Notes by the Way," _Camera
Work_, no. 2 (April 1903), p. 52.

27 Alfred Stieglitz, "_Camera Work_ Introduces
Gertrude Stein to America," _Twice a Year_, nos. 14-15
(Fall-Winter, Spring-Summer 1946-47), p. 193.

CHAPTER 5

THE SYMBOLIC PHASE

Stieglitz and the Dynamics of Being

Borderlines between varieties of human activity are
apt to depend upon one's point of view, and Stieglitz's
public life offers no exception to this generality. For
the sake of clarity, however, I have divided his career
into active and static periods, admitting from the
start that such a dichotomy is artificial, since no life
is ever quite static. The distinction is useful, never-
theless, in charting the growth of a unique symbol as it
emerged from the vortex of Stieglitz's manifold activi-
ties; and we can see his transition from active to
static roles, relatively speaking, in Waldo Frank's
1929 commentary on the nature of his leadership:

> To name an American in whom is the
> essence of leadership as I define it,
> I must leave the scale of national
> figures, the medium of ideas; and
> converge on personal experience.
> Alfred Stieglitz has been a great
> force in the lives of Americans
> through the fact that his life is a
> sheer articulation of his values.
> Not words, not a philosophy at all,
> inform these values; they are made
> whole by their enactment in private
> contact with persons.[1]

Here Frank wants his readers to realize that Stieg-
litz made himself felt in America not only because he
acted upon his values but also because he emblematized
them. As time passed, his actions subsided further
into the symbolic mode. As Jean Toomer said, a few years
later, "No one would mistake him for one of our publi-
cized men of action. No, he has the dynamics of being.
. . . Wherever he is, he is."[2] Thus Stieglitz became,
especially in the literary mind, the objectification
of a complex value system and the embodiment of a
spiritual meaning not otherwise expressible--in other
words a symbol. Since Stieglitz's post-291 force
depended not so much upon what he was doing as upon

what he stood for, I regard his function after 1917 as essentially static--with no pejorative connotation intended.

Stieglitz's metamorphosis into a symbol explains how he continued to influence the lives of Americans after more or less sequestering himself behind the walls of his later havens, the Intimate Gallery and An American Place. Though others interpret his evolution differently, I see a distinct watershed in his labors: in 1917 the United States' declaration of war against his beloved Germany seemed to him the ultimate triumph of commercialism over spiritual values; and the nearly simultaneous dispersal of the 291 group and the withering of Camera Work combined to traumatize him into virtual silence, as far as the general public was concerned, until his one-man show at the Anderson Galleries in 1921.

Of the years between 1917 and 1921, Herbert J. Seligmann, a contemporary observer of Stieglitz, told me in a letter that the photographer "was very much alone, felt rejected, and was for many reasons unhappy." Even during the periods of the Intimate Gallery and An American Place (from 1925 until his death in 1946), Stieglitz concentrated on private, personal contacts, and limited his efforts to sustaining the careers of a select group of American artists. This is not to say, however, that the last three decades of his life were ineffectual. Far from it, for a myth can grow into a symbol and move men more compellingly than exhortation.

In his last essay on Stieglitz, Waldo Frank concludes that "a man's historic importance depends not merely on his intrinsic traits but on the use that is made of him by following generations."[3] If this is true, and I believe it is, then, by extension, Stieglitz's significance in his own time depended in large measure on the symbolic capital that his contemporaries made of him. And indeed they did, especially the writers. Consider Sherwood Anderson. After a conversation with the author, Paul Rosenfeld reported to Stieglitz: "He spoke very appreciatively about you in his own tones, and I was again struck by the curious manner in which you become for people not only a person

but a symbol when you enter their lives. I suppose we all do to a certain extent, but you seem to become a symbol animated from way down within."[4]

Rosenfeld's "again" suggests that this was no isolated instance of Stieglitz's transformation into a symbol. And "animated from way down within" repeats Frank's "his life is a sheer articulation of his values." Thus it was that even though the Photo-Secession officially ended in 1917 with the last issue of Camera Work and the closing of 291 Fifth Avenue, the spirit of the movement lived on in Stieglitz, and 291 the place became "291" the man. In tribute to this avatar Rosenfeld habitually greeted Stieglitz as "291."

Sherwood Anderson, perhaps the most eloquent of the writers who saw Stieglitz as a symbol, was also the most idiosyncratic. The storyteller's habit of refracting people through his imagination until they became, in William Faulkner's disparaging terms, the "figments and symbols of his own fumbling dream,"[5] makes Anderson a biographer to be approached with caution; but in Stieglitz he rightly recognized a man infused with the spirit of place. He raised this recognition to the symbolic level in a brief tribute entitled "City Plowman."[6] Projecting his own yearning to root himself in the land, Anderson likened Stieglitz to a pastoral figure named Uncle Jim Ballard, a man so close to his Sandusky, Ohio, farm that his greatest love was plowing his fields--thus Anderson's odd epithet for Stieglitz, "City Plowman."

Despite Anderson's fallacy of projection and his subjective idealism,[7] this essay augmented the growing reception of Stieglitz as the archetypical American, the figure in whom and through whom we would find our sense of national identity. Anderson believed that he too was "the American Man," but Stieglitz's candidacy was more widely received.[8] The photographer's lifelong search for true American values--in the spirit of Emerson and Whitman, and ending in like frustration-- gave impetus to Waldo Frank's Our America (1919) as well as to The Re-discovery of America (1929) and found its supreme form in America and Alfred Stieglitz (1934), the festschrift in which Anderson's "City Plowman" appears. And in a spirit that superseded his earlier

cosmopolitanism, Stieglitz named his final gallery An American Place. The international phoenix of 291 regenerated itself as the American eagle.

In addition to interpreting his beloved friend as a city plowman, Anderson, in a different context, stressed integrity as a key factor in the Stieglitzian symbol. "You are the one man," the author told Stieglitz, "who never goes cheap, gets tired of decency in the effort toward decency or who gives way to the American tiredness that runs into smartness."[9] To a large extent, the kind of integrity Anderson alluded to was the result of Stieglitz's aversion to commercialism. His early encounters in the photoengraving trade led him to conclude that "to do business in this country it seems necessary to have a policeman on one side and a lawyer on the other."[10] Believing all men to be as honest as himself, the naive young Stieglitz had accepted job orders secured solely by the client's word, only to find his company repeatedly swindled. Worse, the workmen in the shop itself were concerned only with wages and working hours, the pursuit of excellence did not interest them as it did Stieglitz, and they spurned the benevolent paternalism of his "one family working together for a common good."[11]

Embittered by deceptive business practices and shielded by a small but adequate independent income, Stieglitz abandoned commercial enterprises forever, and at the same time converted this rejection into a positive ideal, that of the "true worker," defined here as the "quality worker."[12] Ironically, the true worker concept insulated Stieglitz from the labor movements of his time, whether represented by a national figure like "Big Bill" Haywood or by a humble delegation of tailors.[13] American labor might abandon its commitment to quality in the continuing battle for larger shares of the profits, but Stieglitz never ceased to uphold every worker's inalienable right to do his best work. "My whole life," said the champion of excellence a few years before his death, "has been really dedicated to the fight for all those, in whatever field, who insist on doing their work supremely well."[14] Given the inexorable growth of mass production and the resultant shift in goals from best to more, is it any wonder that

Stieglitz was cynical?

The photographer's indictment of the decay of qual-
ity under commercialism found a sympathetic ear in Sher-
wood Anderson, for it paralleled the anti-industry theme
he had woven into his early novels. Near the end of
Windy McPherson's Son, for example, the protagonist
ponders a hellish emblem of the system he himself had
believed in for a time: a huge, avernal factory in which
human figures scurry about in the glare of a furnace
fire. The Stygian atmosphere of the scene is not unlike
that of Stieglitz's train yard picture The Hand of Man,
admitting that Anderson wrote the novel long before
seeing Stieglitz's photograph.

The question of quality and craftsmanship looms
large in Poor White, to cite another example. Anderson
depicts a "terrible kind of revolt against the machine"
when harness maker Joseph Wainsworth kills the man who
humiliated him by making him sign an order for machine-
made harness. In this symbolic execution scene, crafts-
man Wainsworth virtually decapitates his tormentor with
a harness maker's knife--one of the very hand tools
being made obsolete by machines.

Reviving the anti-machine theme in a 1931 lecture
on "America: A Store House of Vitality," Anderson again
presented his thesis that machines, although neutral in
themselves, have robbed men of their creative masculin-
ity. Here, however, he diverged from Stieglitz, who,
for all his hatred of profit-orientated industrialism,
was barred from focusing his wrath on the machine it-
self because as a photographer he was wedded to the
camera-machine. In heading the Pictorial Photography
movement he had frequently been at pains to prove that
the camera was a mere tool and did not prevent photog-
raphy from rising to the level of art. The painting
versus photography debate that raged at the turn of the
century had hinged on the question of photography's
"mechanicalness." Stieglitz's pictures had furnished
proof to the world that the camera was no impediment to
artistic expression, and he was widely received as the
man who had subjugated the machine to the purposes of
life and art. Asked Anderson, "Has he not fought all
his life to make machinery the tool and not the master
of men?"[15]

It was Stieglitz's consummate craftsmanship that
etched his figure in clear relief on Anderson's con-
sciousness. In a 1925 magazine article the author
spotlighted Stieglitz as the fusion of craftsman and
artist, validated as such by the photographer's compel-
ling emotion toward his work: "To me and to many other
men I know, his figure has been sharply defined as the
type of the old workman whose love of his tools and his
materials has been so passionate that he has emerged
out of the workman to become the artist."[16]

True, Stieglitz referred to photography as his
"passion," and that term is justified by the depth of
emotion in his pictures, but the real object of his
ardor was life, not things. Anderson was mistaken in
believing that Stieglitz had any particular love for
tools and materials, or that a workman metamorphoses
into an artist because of his affection for such things.
Rather than making the craftsman and the artist identi-
cal, as Anderson supposed, their attitudes toward tools
actually separate the two types. The craftsman perhaps
may cherish the implements of his trade, but the artist
regards them only as the means to an end.

This love-of-tools figment simply projected one of
Anderson's own quirks; in another place he wrote about
the "indescribably sweet" feeling he experienced in the
presence of "great stacks of clean white sheets [of
writing paper]."[17] Whatever clue this ingenuous admis-
sion may offer to Anderson's libido, such fetishism did
not manifest itself in Stieglitz. Aside from a hand-
ful of early articles on some technical aspects of
photography, Stieglitz was remarkably silent about the
material side of his calling. Like most true photog-
raphers, as opposed to the gadget-ridden hobbyist, he
rarely talked about his cameras, and when he did there
was no discernible passion in his remarks. He did
admire quality in all things, and he sometimes worked
himself into a cold fury over faulty equipment or
shoddy materials--a balky tripod, say, or printing
paper willfully degraded by the manufacturer. But this
is not love of tools and materials; it is hatred of
hindrances.

If Anderson gave definitive form to the Stieglitz-
as-craftsman symbol, it was another writer, Theodore

Dreiser, who announced its birth. Writing in 1899 the first of three magazine articles on Stieglitz, young free lance Dreiser paid particular attention to his subject's skill in the darkroom. As evidence that "a great photograph is worth years of labor to make," Dreiser explained the several time-consuming operations performed by Stieglitz in creating The L in a Storm, steps that included enlarging the negative, reducing contrast, holding back parts of the negative, bringing others forward--until, months later, the photograph "had grown into an eleven-by-fourteen print, a gem of art."[18]

In the third article, three years later, Dreiser detailed two print controls that Stieglitz, together with several of the Pictorial Photographers, used at the time: the glycerin method of selective development and the bichloride of gum technique of color addition.[19] These operations multiplied the photographer's handwork and insured that every print was in effect an original production, not a mere mechanical copy. To Dreiser, a young man from the Indiana province, such craftsmanship was the essence of artistry, but he was mistakenly valuing a work of art according to the amount of labor entailed, a confusion still prevalent in the popular mind.

In the process of describing Stieglitz's craftsmanship, Dreiser's interview clarified the photographer's attitude toward the much debated question of manipulation. Speaking years before the apotheosis of straight photography, Stieglitz told Dreiser without the slightest hesitation that individualism was his secret and that he was "unhampered by conventionality--unhampered by anything--not even the negative."[20] This statement refutes the notion that Stieglitz was always committed to straight, unmanipulated photography. Freedom in the darkroom, as in all areas of human activity, was this artist's only commitment, although admittedly he abandoned obtrusive manipulation in his later work in favor of emphasizing what he called the underlying laws.

But craftsmanship was not the main trait that Dreiser detected in Stieglitz. In all three articles the "master of photography" stands out sharply as a

symbol of success. Following the slant of the money-
oriented magazines for which he was writing, the Horatio
Alger ideals of his readers, and above all his own value
system, Dreiser documented Stieglitz's success with such
data as the price of his prints ("from fifty to one
hundred dollars" each), his eminence as vice president
of the lavishly endowed Camera Club of New York, and
the quantity of medals ("about 140") that his photo-
graphs had been awarded. About aesthetic qualities
Dreiser said little, relying perhaps on the accompany-
ing photographs to speak for themselves. He did write
of the "poetic insight" of one photograph, however, and
it must have permanently impressed itself on his mind,
for it surfaced in one of his novels some sixteen years
later. The photograph was Stieglitz's famous _Winter,
Fifth Avenue_ (1893), and Dreiser reincarnated it as a
painting by protagonist Eugene Witla in _The "Genius"_
(1915).[21]

Even though Witla's fictive paintings follow the
style of the Ash Can school and although street scenes
were the typical subject matter of this genre, one
painting described in the novel is so like _Winter, Fifth
Avenue_ in all its details that I have come to conclude
that Dreiser not only remembered the photograph but even
may have had a copy of it at hand when he composed _The
"Genius."_[22] To be equally persuaded, the reader has
only to compare the photograph, point by point, with
Dreiser's description of Witla's painting. In the novel
artist Witla has just opened a portfolio of his paint-
ings (in reproduction) for the appraisal of art dealer
Anatole Charles:

> M. Charles looked at them curiously.
> . . . Looking at one of Fifth Avenue
> in a snow storm, the battered shabby
> bus pulled by a team of lean, unkempt,
> bony horses, he paused, struck by its
> force. He liked the delineation of
> swirling, wind-driven snow. The
> emptiness of this thoroughfare, usu-
> ally so crowded, the buttoned,
> huddled, hunched, withdrawn look
> of those who traveled it, the excep-
> tional details of piles of snow
> sifted on to window sills and ledges

and into doorways and on to the
windows of the bus itself, attracted
his attention.[23]

Of the several details noted by M. Charles, the
only one missing from Winter, Fifth Avenue is that
involving the bus's windows. In Stieglitz's photograph
the windows of the blizzard-lashed vehicle--Stieglitz
said it was a stagecoach--are not visible. The other
details match almost to perfection, and the atmospheric
"force" of both scenes is identical. Of the photograph,
Dreiser writes, "The driving sleet and uncomfortable
atmosphere issued out of the picture with uncomfortable
persuasion. It had the tone of reality."[24] Of the
painting, M. Charles says approvingly to Witla, "I can
feel the wind."[25] Surely this is more than coincidence.

Even more indicative of the essentially photograph-
ic nature of Witla's art is the fact that, although
the dealer alludes to Witla's "color composition" and
"color work," the Fifth Avenue painting is described
entirely in tones of black and white. ("A symphony in
grey" is Charles's tag for another of Witla's paintings,
one revealing many of the exceptional details found in
Stieglitz's 1903 photograph In the New York Central
Yards.) The province of painting of course includes
the rendering of light and shade as well as of color,
but photography at the time Dreiser wrote The "Genius"
was still in the main restricted to black and white,
and one of Stieglitz's special achievements was the
depiction of life, in Paul Rosenfeld's words, as a
"significant play of chiaroscuro."[26]

Ellen Moers has reminded us of Dreiser's debt to
painter Louis Sonntag as his mentor in art.[27] But the
young journalist was also receptive to lessons from a
photographer. Midway in his last interview with Stieg-
litz, Dreiser allowed himself a photographic jeu
d'esprit:

We had walked over to the west wall of
the building [housing the Camera Club
of New York] and stood watching the
panorama of roofs and spires and jet-
ting steampipes, and the narrow
grottoes of streets, in the depths

of which the turgid stream of human-
ity flowed noisily. Lower New York
and the Harbor were a <u>fogged negative</u>;
Brooklyn Bridge was an <u>indistinct
detail</u> of sweeping lines which seemed
to be <u>responding quickest to the
touch of a developer</u>. The "noble
Hudson" and a few gilded towers were
the only <u>accents of shimmering light</u>
in the vast waste of buildings.

As Mr. Stieglitz leaned against
the wall, talking enthusiastically,
his hatless head--<u>sharply defined
against the bright sky</u> which was
preparing for sunset over New
Jersey--made a <u>picture for his own
artful camera</u>. His sensitive face--
dark, piercing eyes, firm mouth, and
sharp, forceful chin--under its
thatch of black hair, explained why
the [Photo-Secession] movement he
chose to champion in this country
was meeting with recognized success.[28]

Dreiser here was willing to experiment in prose
with the techniques and even the vocabulary of photog-
raphy, but at the end of the interview he came back to
his dominant theme: Stieglitz the symbol of success.[29]
In discussing the evolution of this symbol, I have been
forced to double back to his "active," pre-1917 period.
Now it is time to return to his "static" postwar career
and to conclude with what is perhaps the most highly
conceptualized version of the Stieglitzian symbol ever
distilled in the literary consciousness. I refer to
Waldo Frank's doctrine of the "true person."

Although Frank rejected Oswald Spengler's separa-
tion of culture into "monadlike" units, he shared the
German historian's vision of the decline of the West.
But according to Frank's diagnosis, the atrophy of
European civilization was a syndrome stemming from a
particular source, namely the dualism that has charac-
terized our world view since Socrates dichotomized the
universe into spirit and matter. If such dualism is
sickness, then monism is health; and in both his novels
and his criticism Frank proclaims our salvation to be

a return to "wholeness," the reintegration of man and cosmos. In modern times only the East, Frank writes in "The New World in Stieglitz," still points the way to oneness. In the West only Marxism, by eliminating economic classes, seems to be moving toward unity. (Frank was one of the group of American intellectuals who subscribed to the communist theorem in the 1930's.) Integrity, in the radical sense of wholeness, thus becomes Frank's catholicon; and looking about the American scene for a usable symbol of ideal unity, he settles on Stieglitz as the nearest living approximation. To authenticate Stieglitz as the "true person," Frank, in this his last tribute to the photographer, revives the Hegelian dialectic and plots Stieglitz's life as an "ethical triad" of thesis, antithesis, and synthesis.[30]

In Stieglitz, claims Frank, the "thesis" is the "acceptance by the man of all life . . . in the mystic sense of knowledge of the self as belonging to the whole, and of knowledge of the whole as belonging to the self." Like other pronouncements by Frank, this one is rather ambiguous out of context; it takes him some four pages in the essay to explain what he means. The concrete manifestation of the "thesis" is, expectedly, Stieglitz's photographs. These reveal his fundamental affirmation of life in its essence and in its myriad forms. But Frank makes clear that Stieglitz's acceptance is not mindless contentment, not the indiscriminate toleration of both good and bad. The "dynamic recognition" that Frank attributes to Stieglitz seems to me much closer to the Hindu doctrine of Atman than to the philosophic optimism of Gottfried Leibnitz or Alexander Pope--though Frank does not mention either Atman or optimism. Instead, he cites such "mystic artists" as William Blake "recording his poem to the Tyger" and, quaintly, "Saint Francis preaching his adorable sermon to the birds."

The "antithesis" of Stieglitz's life is simple enough, according to Frank, if rather paradoxical. It is the "refusal of everything that refuses, implicitly or actively, his thesis." The "everything" here includes "our business, our politics, our laws, our morals, our popular arts"--in sum the whole "bourgeois-capitalist" world. But Frank knew better than to cast

79

his apolitical hero as a Marxist. Stieglitz's "refusal of the present American world," Frank explains, "is but the function of what is positive and enduring in the American world." Under Stieglitz's scathing criticism of contemporary mores lies an abiding faith in the country's ideals, ideals that Frank, in unison with Granville Hicks, sums up as the "Great Tradition."

"Thesis and antithesis, together, make the person," concludes Frank, and this "synthesis" precipitates the "integral person" in the form of Stieglitz. As the realization of the ideal synthesis, the photographer additionally symbolizes the promise of a future society (the "new world" of the essay's title) in which such "true persons" can live.

Leaving Frank for the time being, we find that, on a more mundane but still influential level, Stieglitz's wide reputation for integrity (in the popular sense of independent rectitude) accrued over the years from the honesty of his photographs and his gallery exhibitions, from the meticulous standards of Camera Work, and especially from his intentionally unbusinesslike way of pricing the works in his galleries according to the buyer's sincerity. A John Marin watercolor might go for as little as five dollars to someone who seemed willing to cherish its spirit, but a coldly calculating millionaire would find the same painting tagged at the maximum he would pay, perhaps more.

Whatever the work brought, the entire sum went to the artist, for Stieglitz's galleries were strictly non-profit establishments. All these factors made him a hero of anti-commercialism in the public eye, even though his detractors saw only snobbery and perversity in such behavior. Admittedly, Stieglitz's financial integrity was predicated on the modest income--some $1,200 a year--settled on him by his rather well-to-do father; but a less dedicated person might have used his economic security to pursue a life of refined dilettantism. Stieglitz, however, took advantage of his independence to transcend, in Waldo Frank's resonant words, the "fixed limits of any established cultural status" and, thus liberated, "to forge the parabolas of chaos into unitary form."[31]

My final observation on Stieglitz's symbolic
integrity concerns the way in which his thinking
paralleled existentialism and perhaps even anticipated
its advent in this country. First, as we have seen, at
the core of the Stieglitzian symbol lay the fusion of
values and actions. But which came first? For cen-
turies Western man has believed that actions emanate
from values contained in the preexistent nucleus of
being usually called the soul. But existentialists
such as Jean-Paul Sartre reversed the relationship and
asserted that existence (actions) precedes essence
(being, soul, values).

With this new metaphysical order Stieglitz evi-
dently agreed. "Most people seem to think that the
word came first and then the act," declared the photog-
rapher, "but it was quite the contrary; that much I
know."[32] Putting it another way, he said, "Words,
after all, have little meaning for me. How do the
people through their action show what influence for
good I may have had? Influence I may have had, not
through my words but through my actions and through
what I have produced in so many ways."[33] In rejecting
communism he stated, "Unless whatever a man does is a
symbol of the thing he claims to be fighting for--then
what he says and what he is fighting for can have no
significance."[34]

Stieglitz's essence, then, was defined, especially
in later life, as the aggregate of his existence, and
his actions became increasingly symbolic of his being.
In Sartre's play No Exit, the lesson of hell is that a
man is what he has done, not what he meant to do--a
truth that Conrad's Lord Jim also learns when the
heroic fantasies of a lifetime are dashed by a single
act of cowardice. Phrasing the philosophical parallel
in another fashion, Dorothy Norman observes, "Stieglitz
might easily be thought of in terms of Existentialism,
or Zen Buddhism, since what preoccupied him most was
the reality of experience itself; the process of
becoming, rather than theory about experience, or the
'finished product.'"[35]

Also like the existentialists, Stieglitz was sar-
donically determined to make the best of the situation

in a civilization that seemed bent on proving itself
absurd and meaningless. His antagonism toward the
contemporary Establishment was the diametric opposite
of his cosmic optimism, but the conflict of the two
within his mind had at least this fortunate result: it
precipitated some of his greatest photographs, notably
The Steerage, The Terminal, and Winter, Fifth Avenue.

But the tension in Stieglitz between optimism and
pessimism could not always be so happily resolved.
Consider the existentialistic resignation in this state-
ment, made by the man who spent most of his life advanc-
ing the cause of art in America: "I knew beforehand
that in trying to interest the American public in art,
I was beaten."[36]

In our pantheon of national heroes, it was not the
idealized George Washington that attracted Stieglitz as
a child. Rather, he admired the relatively obscure
Nathanael Greene, the Revolutionary War general who
appeared to lose battles but who triumphed in the end
because he sacrificed fewer men than the enemy and
conserved his vital resources. In like spirit Stieglitz
said, "When I undertook to publish Camera Work I made
up my mind at once that the money I proposed to spend--
one thousand dollars--was lost."[37] The money was indeed
lost, but in every other way Camera Work prevailed--an
irony that General Greene would have joined Stieglitz
in relishing.

This existentialistic frame of mind explains why
Stieglitz appeared to take satisfaction in the death of
the finest photographic journal America has ever seen.
How could it live, he seemed to ask, in a world that
values matter over spirit, things over life? Ruefully
he observed: "I am told that once upon a time there was
a man named Diogenes looking for an honest man. . . .
I, too, am on a search, maybe more difficult than the
one of Diogenes. I happen to be looking for an intelli-
gent American."[38] His search, alas, was never rewarded,
but, like one of Albert Camus' characters, he "believed
himself to be on the right road--in fighting against
creation as he found it."[39] Stieglitz contended against
society as he found it. Only through individual action
can man hope to improve himself and society--in this
belief the existentialists and Stieglitz concurred.

NOTES

CHAPTER 5

[1] Waldo Frank, <u>The Re-discovery of America: An Introduction to a Philosophy of American Life</u> (New York: Scribner's, 1929), p. 177. The statement appeared earlier in his "Our Leaders," <u>New Republic</u>, June 20, 1928, p. 116.

[2] Jean Toomer, "The Hill," in Frank, <u>America & AS</u>, p. 296.

[3] Waldo Frank, "The New World in Stieglitz," in Frank, <u>America & AS</u>, p. 213.

[4] Paul Rosenfeld to AS, Sept. 14 [1922].

[5] William Faulkner, "Sherwood Anderson: An Appreciation," <u>Atlantic</u>, June 1953, p. 25.

[6] Sherwood Anderson, "City Plowman," in Frank, <u>America & AS</u>, pp. 303-08.

[7] "May it not be that all the people we know are only what we imagine them to be?" Anderson asked one of his lecture audiences; reprinted in <u>The Sherwood Anderson Reader</u>, ed. Paul Rosenfeld (Boston: Houghton Mifflin, 1947), p. 342.

[8] "Nearly all the qualities of the Americans of my time are embodied in me," Anderson informed a young lady correspondent; quoted in William Alfred Sutton, <u>Exit to Elsinore</u> (Muncie, Ind.: Ball State Univ. Press, 1967), p. 41. In another place he styled himself as "the American Man . . . a kind of composite essence of it all"; quoted in Brom Weber, <u>Sherwood Anderson</u> (Minneapolis: Univ. of Minnesota Press, 1964), p. 40.

[9] Sherwood Anderson to AS, Aug. 11, 1927; in the Newberry Library.

10 Alfred Stieglitz, "Four Happenings," Twice a Year, nos. 8-9 (Spring-Summer, Fall-Winter, 1942), p. 113.

11 Ibid., p. 109.

12 Ibid., p. 118.

13 Alfred Stieglitz, "Ten Stories," Twice a Year, nos. 5-6 (Fall-Winter, Spring-Summer 1940-41), pp. 136-37, 138-39.

14 Alfred Stieglitz, "Thoroughly Unprepared" and other stories, Twice a Year, nos. 10-11 (Fall-Winter 1943), p. 262.

15 Sherwood Anderson, "Alfred Stieglitz," New Republic, Oct. 25, 1922, p. 217; rpt. in his Sherwood Anderson's Notebook and in his The Sherwood Anderson Reader, the latter edited by Paul Rosenfeld.

16 Ibid.

17 Anderson, A Story Teller's Story, p. 290.

18 Theodore Dreiser, "A Master of Photography," Success, June 10, 1899, p. 471.

19 Theodore Dreiser, "A Remarkable Art," Great Round World, May 3, 1902, pp. 430-34.

20 Ibid., p. 434.

21 Dreiser cites Winter, Fifth Avenue by title in "The Camera Club of New York," Ainslee's, Oct. 1899, p. 329. Also, in the slightly earlier "A Master of Photography," he refers to Stieglitz's published edition of twelve photogravures. That edition--released as Picturesque Bits of New York and Other Studies (New York: R. H. Russell, 1897)--includes Winter, Fifth Avenue. First labeled Winter on Fifth Avenue or

21 (cont.) Winter--Fifth Avenue, the photograph was Stieglitz's "most exhibited, reproduced, and prize-awarded print," according to friend and colleague Edward Steichen.

22 In his study of the parallels between fictive Eugene Witla and real-life Everett Shinn, Joseph J. Kwiat states that there are "striking pictorial similarities" between Witla's Fifth Avenue in a Snow Storm and three of Shinn's paintings ("Dreiser's The 'Genius' and Everett Shinn, the 'Ash-can' Painter," PMLA, 67 [1952], 15-31). Such similarities are indeed detectable, especially in Shinn's A Winter's Night on Broadway (1900) and West 57th Street, New York (1902); but I still aver that the single model most like Witla's painting is Stieglitz's Winter, Fifth Avenue (1893).

23 Theodore Dreiser, The "Genius" (1915; rpt. Cleveland and New York: Forum-World, 1963), p. 227. If Stieglitz ever recognized his contribution to Witla's painting, he did not comment on it in anything I have seen.

24 Dreiser, "The Camera Club of New York," p. 329.

25 Dreiser, The "Genius," p. 227.

26 Paul Rosenfeld, "The Photography of Stieglitz," Nation, March 25, 1932, p. 351.

27 Theodore Dreiser, "The Color of Today," Harper's Weekly, Dec. 14, 1901, pp. 1272-73; quoted in Ellen Moers, Two Dreisers (New York: Viking, 1969), p. 39.

28 Dreiser, "A Remarkable Art," p. 433; italics added.

29 For an account of the "formula" that Dreiser followed in writing his 1898-99 series of profiles for Success magazine, see Richard Lehan, Theodore Dreiser:

29 (cont.) His World and His Novels (Carbondale: Southern Illinois Univ. Press, 1969), pp. 37 ff.

30 All quotations and paraphrases regarding the "true person" symbol derive from Frank's "The New World in Stieglitz," in Frank, America & AS, pp. 212-24.

31 Waldo Frank, In the American Jungle (1937; rpt. Freeport, N.Y.: Books for Libraries, 1968), p. 152. Frank did not name Stieglitz here, but the photographer certainly fits Frank's description of the "religious artist."

32 Alfred Stieglitz, quoted in Dorothy Norman, "From the Writings and Conversations of Alfred Stieglitz," Twice a Year, no. 1 (Fall-Winter 1938), p. 103.

33 Alfred Stieglitz, "Four Happenings," Twice a Year, nos. 8-9 (Spring-Summer, Fall-Winter 1942), p. 167.

34 Alfred Stieglitz, quoted in Dorothy Norman, "An American Place," in Frank, America & AS, p. 143; italics added.

35 Dorothy Norman, Alfred Stieglitz: Introduction to an American Seer (New York: Duell, Sloan and Pearce, 1960), p. 48; hereafter cited as Norman, AS: Intro.

36 Alfred Stieglitz, quoted in Seligmann, AS Talking, p. 89.

37 Ibid.

38 Alfred Stieglitz, "Three Parables and a Happening," Twice a Year, nos. 8-9 (Spring-Summer, Fall-Winter 1942), p. 170.

39 Albert Camus, The Plague, trans. Gilbert Stuart (New York: Modern Library-Random House, 1948), p. 116.

CHAPTER 6

EMBEDDED IN A UNIVERSAL MATRIX

Stieglitz's Reading

Emerson said that when one "can read God directly, the hour is too precious to be wasted in other men's transcripts of their readings." Stieglitz would have agreed. He might even have added, paraphrasing The American Scholar, that books are for the photographer's idle times. Indeed, he read the face of the Life-Spirit, his God, directly through the camera lens; and only when his own "seeing" waned because of illness or fatigue did he resort to other men's verbalized experience. "Reading for me always means a non-creative state," he half-apologized to Waldo Frank after mentioning that he was reading a new English edition of Oswald Spengler.[1]

To illustrate his opinion of other men's ideas, especially in philosophy, Stieglitz liked to relate an incident that occurred once when he was confined to bed by sickness. Unable to make photographs, Stieglitz asked his wife to place some books by his bedside. The invalid then picked up a volume of Nietzsche, a philosopher he had never read before.

> I happened to open the book at a
> particular page [Stieglitz said],
> and on this page I saw written:
> "There are three classes of human
> beings: the artist, the scientist
> and the sportsman." I put down the
> book and felt that this was all I
> needed to read. . . . I found that
> what Nietzsche had said was true
> for me from what I knew of life.[2]

Words, however profound, might confirm Stieglitz's experience, but they could never supersede it. Life, for him as for Emerson, was the great teacher.

Stieglitz's disdain for conventional intellectual disciplines was, as one might expect, a stumbling block in his academic advancement. By his own testimony, the

reason he did not receive a doctorate after some eight
years of study in Berlin was his independent attitude
toward the university curriculum. He later explained:

> I refused to waste my time . . .
> studying all kinds of things by rote.
> Philosophy and the rest. I could
> get my own philosophy, I felt, but
> from living. I sensed that then
> finally the day would come when I
> would take up the philosophers and
> would find that they and I had
> arrived at very similar conclusions
> about life. Not necessarily at
> identical philosophies, but our
> experience would be similar.[3]

A study of Stieglitz's reading habits might there-
fore be expected to disclose those "very similar
conclusions about life" that he shared not only with
philosophers but with other writers as well. He served
fair notice that he turned to books for the corrobora-
tion of personal experience rather than for original
insights into life; but great literature--especially
Goethe--did produce in him the effect that someone
called an "echo inside"; and, as we have seen, the
young Stieglitz read the story of Nathanael Greene as
an exemplum of sensible heroism. He was not as impervi-
ous to other people's ideas as he thought.

Stieglitz's philosophy was eclectic. In his will-
ingness to subordinate books to life he followed the
anti-intellectual tradition of nineteenth-century
Romanticism; but his commitment to the reality of experi-
ence paralleled, in his own time, the empiricism of
William James and the experimentalism of John Dewey.
In the latter vein he often referred to his galleries
and even to Camera Work as laboratories in which he
tested the aesthetic IQ of the American public. His
"instruments of measurement" were sometimes the viewers,
sometimes the works of art themselves, depending upon
which of the two he had previously calibrated.[4]

A controlling factor in Stieglitz's reading was
his distinction between rules and laws. Rules were
man-made and therefore frangible, as he revealed in

talking about his childhood: "I never liked to do things according to rules. Whether it was with _Parchesi_ or _Steeplechase_, or any other game, I always made up my own rules."5

If anything characterized Stieglitz as a child of Romanticism, it was his rejection of rules--and of any other arbitrary restriction of man's, and especially the artist's, freedom and individualism. But he was no mere nihilist. The reason he felt free to follow his own rules was his conviction that "fundamental laws" governed all actions. He explained:

> If I would do a particular thing in
> a particular way, I would be told it
> was against the rules. And I would
> feel that then in time the rules
> would have to be changed. For I did
> only what was natural to me. So if
> natural for me, it must be natural
> for others, and therefore, in time,
> the way I did it would have to be
> accepted.6

Stieglitz was of course wrong in thinking that there was any necessary correlation between his own rules and the laws of nature. Emerson made the same mistake. But Stieglitz's intuition of universality, concurring with the innate aversion to rules, made possible some landmark photographs. Told that natural light was essential to the photographic process, young Stieglitz took his camera into a cellar and successfully exposed a plate by the light of a single electric bulb. The exposure required twenty-four hours, but it opened up the whole realm of available light photography. And later, while others still regarded photography as "sun painting," he worked in rain and snow-- even in a blizzard--to create such prodigies as _Winter, Fifth Avenue_. But more important, his major photographs peer beyond mere objects into the very hypostases of creation, into the "natural forces that fill heaven and earth," as Maurice Maeterlinck said, hailing photography in the second issue of _Camera Work_.

A Romantic revolutionary in some of his youthful attitudes, Stieglitz in his final wisdom emphasized

that all art mirrors the "supreme order" of life.[7] In
this belief we see his underlying allegiance to classi-
cism, although he would have disputed the ancients'
claim that art imposes order on the chaos of nature,
and he certainly would have opposed the neoclassical
critics and their worship of rules. At times, however,
his faith that man is part of that order seemed to
waver: he once said (echoing Calderón, Poe, and Mark
Twain) that life is a dream. What is more, the "act of
creation" is a dream within a dream.[8]

Is art then mere illusion? No, Stieglitz probably
had in mind, though he did not elaborate, the concept
of the dream as an ordered revelation or an emblem (he
would have said an "equivalent") of something submerged
in the unconscious--a theory supported by both Sigmund
Freud and Havelock Ellis. Indeed Stieglitz's most
dreamlike creations, his cloud pictures, disclose not
formless nebulosity but a sublime harmony. He called
them his "documents of eternal relationship--perhaps
even a philosophy." That philosophy, grounded on all-
pervading law, confirmed his self-reliance and insured
the evolution of his photography along the lines of
absolute idealism.

If Wordsworth is right and the child is father of
the man, then there should be some profit in reviewing
Stieglitz's early reading for sources and foreshadow-
ings of his later ideas and mature philosophy. Fortu-
nately we have two available springs of information:
the commonplace book he kept during his Berlin student
years and the reminiscences he published in later life.
The commonplace book is labeled Extracts, etc. Begun
November, 1884. At the time he began to collect these
quotations, Stieglitz, almost twenty-one, was a mechan-
ical engineering student at the Charlottenburg Poly-
technikum in Berlin. Making no claim of being exhaus-
tive, and in fact inviting further investigations, I
would like now to offer a few observations concerning
the thoughts that caught his attention.[9]

Given Stieglitz's youth, it is not surprising to
find instances of jejune skepticism among the quotations.
Here are Aristotle's assertion that no one is a friend
and Shelley's claim that marriage is studiously hostile
to human happiness.[10] Such pessimism is a malady of

the young, and a trace of it carried over into Stieg-litz's mature personality, but even in his twenties he found positive values to counterbalance such nay-saying.

One set of affirmations, which would remain with Stieglitz throughout his life, was supplied by idealism. His third entry, from George Sand, informs the reader that art is not the study of positive reality but the quest for ideal truth. From Goethe, Stieglitz learned that women are the only vessels left into which modern men (Neueren) may pour their idealism. Ludwig Börne finds that mankind in the ideal is noble, even if indi-vidual men are petty. And finally, an unattributed entry perhaps composed by Stieglitz himself says that money is the ideal of most men but that he who has no other ideal is a clod.

All of these entries are perfectly consonant with Stieglitz's world picture, as is the epigram attributed to "S.": a man can do what he wills; what he cannot do, he should not will. This might seem an odd maxim for someone who was in many respects a perfectionist and who saw life as a never-ending struggle against the philistines, but it accords nevertheless with Stieg-litz's deeper principle of controlled sacrifice and with the example of Nathanael Greene: self-immolation in the face of hopeless odds is not noble, merely wasteful.

Although idealism was no doubt the dominant strain in Stieglitz's makeup, it was modulated by definite overtones of pragmatism and empiricism. Thus the first extract in his commonplace book quotes Erckmann-Chatrian to the effect that a person should report only what he himself has seen; that in this way the world would be able to learn truth. The mature Stieglitz modified this precept only to the extent of making the act of seeing stand for total personal experience, rather than for the mere sensory perception implied by Erckmann-Chatrian.

Foreshadowed also in the commonplace book is Stieg-litz's enduring fascination with the feminine principle of creation, the female mystique--an area in which he sometimes verged on sentimentalism. An unattributed entry says that God has forgiven Mary Magdalene but

that men are much harsher. Later on in the extracts someone praises Wagner's music as the "apotheosis of woman." From other sources we know that <u>Tristan and Isolde</u> was one of Stieglitz's favorite operas; he claimed to have heard it over a hundred times.

Perhaps the most metaphysical entry in the book comes from Goethe, in whose writings Stieglitz found gratification throughout his life. The quotation involves the Kantian distinction between reason (<u>Vernunft</u>) and understanding (<u>Verstand</u>). Reason, says Goethe's maxim, points toward "becoming" (<u>Werdende</u>) and does not concern itself with "why"; understanding points toward "have become" (Gewordene) and does not ask "whence." Stieglitz, like Emerson and Coleridge before him, opted for the intuitive faculty (<u>Vernunft</u>), and thus Dorothy Norman was correct in saying that what preoccupied him most was the "<u>process of becoming rather than</u> . . . the 'finished product'"--precisely the distinction between <u>Werdende</u> and <u>Gewordene</u>.

A final point before we leave the commonplace book. I have already commented on the tragic sense in Stieglitz's portraiture. And so I found it significant that during the period he regarded as the most idyllic of his life, he should have copied down Horace Walpole's famous dictum: "The world is a comedy to those who think, a tragedy to those who feel." This is followed quickly by Wordsworth's lament: "A deep distress hath humanized my soul." The one quality of Stieglitz's life that projected itself to even the casual observer was his capacity for intense feeling; and thus, by Walpole's reasoning, his tragic vision of life was a corollary of his sensitivity. Suffering was his daily bread, we recall Waldo Frank saying of the man who elsewhere mentioned unashamedly that, for two years after he returned from Germany, he wept nightly over the inhumanity of New York.[11] But Stieglitz did not wallow in emotion for its own sake. In the end suffering had for him the same function as for his associate and kindred spirit Herbert J. Seligmann; that is, it "unlocked access to deeper modes of being."[12]

Turning now to Stieglitz's recollections of his early reading, we find a convenient summary in "The Boy in the Dark Room," a capsule biography that Paul

Rosenfeld prepared under Stieglitz's scrutiny.[13] There much is made of the youth's encounter with Zola in the 1880's. Coming upon <u>Madeleine Férat</u> after a march through Russian fiction (Lermontov, Gogol, Pushkin, Turgenev, and Tolstoy), young Stieglitz devoured the novel and then sat up all night reading it to his friends. Afterwards he consumed several volumes of the <u>Rougon-Macquart</u> series. Rosenfeld suggests that Stieglitz was attracted here by Zola's "employing fiction experimentally as a means of penetrating to the laws underlying the phenomena of life."[14] Perhaps. But I would also imagine that Stieglitz's acutely emotional nature was stirred by Zola's sensational subject matter and that he relished the Frenchman's image of essential womanhood. For no doubt similar reasons, Stieglitz preferred, among German writing, Scheffel's <u>Ekkehard</u>, "that song of the dignity of woman."[15] Among the Americans only Mark Twain's novels held his interest for a while, but we are not told why he liked Twain, nor why he ignored the other American writers.[16] He probably appreciated Twain's irony, but surely not the satiric portraits of women.

If Zola provided the emotional catharsis during Stieglitz's Berlin years (1881-1890), it was Goethe who did so even earlier and who would continue to be his favorite author. When he was about thirteen and writhing with the first pangs of sex, Stieglitz discovered <u>Faust</u>. "There are two things that attract me in it," the boy replied when his mother asked why he had been reading it for half a year, "Marguerite and the Devil." When queried about Faust himself, young Alfred answered, "He doesn't interest me."[17]

Besides the undeniable possibility that Stieglitz's reading was a safety valve for pubescent storm and stress (he wept as readily for Little Eva as for Marguerite/Gretchen), and noting that Rosenfeld said the boy found the intrigue in <u>Faust</u> "pathetic and mysterious," we see in the conjunction of Gretchen and Mephistopheles an early instance of what later became the basis of Stieglitz's art. For Stieglitz, concrete objects, even forms in nature, had little or no aesthetic importance in themselves. They existed only in relation to something else, most especially to the feelings of the artist. Thus the boy's fixation

on the relationship of contrasting characters foreshadows the emergence of the photographic "equivalents." The Steerage, Stieglitz's greatest single photograph, is, in the words of its maker, a "picture based on related shapes and on the deepest human feeling."[18] This extension of relationship to include emotional states--the synthesis, in effect, of subject and object--was, as he said, a step in his own evolution and a "spontaneous discovery."[19] Even photography itself was "measured in juxtaposition to other media of expression" in the 291 gallery.[20]

Stieglitz did not say why he was attracted by the Gretchen-Mephistopheles combination, but perhaps, like his Italian parallel in aesthetics, Benedetto Croce, he saw in Gretchen a person of pure intuition, similar to himself, in contrast to Mephistopheles' sheer intellectualism. Further, in Gretchen's salvation he may have recognized what Croce called the "affirmation and triumph of idealism in a creature who is at first entirely instinctive and natural," but who, by refusing to leave prison with Faust, reveals the birth of a soul.[21] If there is any common thread running through Stieglitz's life, it is precisely this affirmation of idealism. In all implications Stieglitz's response to Faust meshes with Croce's conclusion that "the tragedy is the tragedy of Gretchen, not that of Faust."[22]

Enticed by Stieglitz's early passion for literary naturalists such as Zola and deceived by the seemingly documentary quality of his New York street scenes, an occasional commentator has sought to link Stieglitz to the artistic-literary stream of realism.[23] Such a connection is erroneous for at least two reasons. First, Stieglitz simply did not subscribe to the realists' faith in matter. He believed that relationships, not objects, were the ultimate reality that the artist should seek, and this clearly subjective attitude created a gulf between him and the realists, both in art and in literature. Many writers visited 291, as much to hear Stieglitz as to see the exhibitions, but realists were noticeably absent from the group, and I believe there was a reason. The idealistic bias of Stieglitz's world must have been at least partly responsible for the fact that, despite Dreiser's early admiration of his work, the novelist's acquaintance

94

with Stieglitz lapsed soon after the 1899-1902 magazine
articles and revived only briefly when Stieglitz sped
congratulations to the novelist for publicly denouncing
America's materialism, intellectual standardization,
puritanical moralism, and spiritual sterility.[24] Stieg-
litz regarded that blast as a personal vindication; but
in response to the photographer's rhapsodic letter,
Dreiser replied casually, "Nice to hear from you, hope
all is well, above is my address if you are passing
by."[25] Dreiser may have felt free to draw upon Stieg-
litz's photography when he composed The "Genius," but
I can find no indication that he ever visited the 291
gallery. He did get around to visiting An American
Place a few years before Stieglitz's death, but after
that visit to his last gallery, the photographer
exclaimed, "I hadn't met Dreiser in 40 years!"[26]

 In "Life, Art and America" Dreiser flayed material-
ism as in An American Tragedy he exposed the shallow
aspirations of Sondra Finchley and Clyde Griffiths; but
nevertheless his novels and those of the realists in
general hewed to the positivist rationale that if
matter is not the ultimate reality, it is at least the
primary stuff of experience. Even knowledge comes to
Eugene Witla not in the guise of ideas but in the
concrete form of women. But for Stieglitz the tangible
world supplied only half of the equation that yielded
reality, and he conceived his highest purpose as aiding
men--"beings with potentials reaching far beyond all
skies & stars"--in realizing their capabilities.[27]
Such a vocation blended the doctrine of perfectibility
with the Romantic ideal of infinite aspirations--a far
cry from the overriding determinisn of writers like
Dreiser. Stieglitz's goal in art was much nearer that
of Sherwood Anderson, and the photographer clearly saw
that both he and the storyteller had progressed beyond
the limits of orthodox realism:

 There is a reality so subtle [Stieg-
 litz told Anderson] that it becomes
 more real than reality. That's what
 I'm trying to get down in photography.--
 That's not juggling with words.--I
 feel you are after a similar thing &
 are working it out in your way as I
 work it out in my way.[28]

The second reason why Stieglitz cannot be consid-
ered a realist involves his attitude toward particular-
ity. The literary realists, especially when writing
novels, based their art on particularized description
and on individualized characterization. They concerned
themselves with the streaks of the tulip, as Dr.
Johnson's Imlac put it, rather than with the universal
archetype of "tulipness." But Stieglitz knew that the
discrete items of experience conformed to fundamental
laws, and he strove to reflect this cosmic orderliness
in his photographs. Even his portraits of individual
artists convey not the impression of separate personal-
ities but rather the sense of the "aloneness of the
artist."[29] Said Stieglitz, "Photography brings what is
not visible to the surface." And again, "Beauty is the
universal seen."[30] The latter definition sounds decid-
edly Platonic, but Stieglitz's idealism did not compre-
hend dualism. Plato held that art merely reflects
objects, which in turn are no more than shadows of the
Ideas (eide); Stieglitz maintained that art was the
absolute fusion of the real and the ideal.

Given Stieglitz's tendency, especially as he grew
older, to express himself in the form of parables, one
might expect to find the Bible among the things he
read.[31] Actually he did receive considerable exposure to
Scripture, but later he minimized the intellectual and
spiritual significance of the experience. Talking about
his school days at a private academy in New York, he
recalled that the daily penmanship exercise, and some-
times the penalty for cheating, was the transcription
of pages of "the Testament," as he called it. "Hence,"
he concluded, "the Testament was combined with the idea
of penmanship in my mind and consequently it held no
interest for me, although the whole school had Bible
class first thing every morning."[32]

One could argue with good logic that, even though
Scripture itself held no interest for Stieglitz, the
daily copying of the Bible ingrained the parable form
in his mind, so that later when he sought to verbalize
profound truths, he automatically followed that pattern.
And even though the Testament may not have attracted
Stieglitz as a boy, such indifference did not carry into
his maturity. In a letter to Paul Rosenfeld, the
photographer, then in his mid-fifties, said that he was

"chiefly" reading the Bible at that time. This later
contact no doubt sharpened the outline of the parables
already impressed on his mind.

One of the most Biblically resonant of Stieglitz's
parables appeared in Twice a Year just a few years
before his death.[33] Entitled "A Bottle of Wine," the
allegory dramatizes Stieglitz's foreboding that what he
accomplished and what he stood for would be dissipated
after his death by his well-intentioned but unenlight-
ened followers. In the story Stieglitz's achievement
is symbolized by a bottle of sacred wine. This wine,
his transubstantiated life's blood, is sacramentally
shared by his disciples and worshiped by pilgrims from
all over the world. While he lives, Stieglitz guards
the wine; but after he dies, his devotees secretly
water down the precious essence. Eventually the world
is full of adulterated bottles, each worshiped by the
ignorant public as The Sacred Bottle.[34]

The parable's symbolism seems to me clear evidence
of the Bible's influence on Stieglitz's thought and
expression. The story also reveals his disenchantment
with his votaries and his evident conviction that none
had proven worthy to become the preserver of the spirit
of idealism.[35] More important, it explains the deeply
conservative nature of a career that was an aesthetic
ministry to the American public. Someone else might
have felt that the spiritual diffusion in the parable
was a noble fate. Not Stieglitz. "Popularization,"
he insisted, "inevitably means low standards."[36] This
principle, if true, justifies the photographer's
elitism--his refusal, for example, to allow the repro-
duction of his pictures except by his own hand. "As
for reproductions," he maintained, "I feel that if the
spirit of the original is lost, nothing is preserved."[37]
Quality was the sine qua non of Stieglitz's canon, and
even William Carlos Williams in his most mordant account
of Stieglitz felt obliged to compliment the photographer
as a "profound prophet of real values as opposed to the
murderous falsity of cash over everything else."[38]

The final source of information about Stieglitz's
reading to be considered here is his correspondence
with his literary friends. The letter writers included

Sherwood Anderson, Waldo Frank, Paul Rosenfeld, and Herbert J. Seligmann. The bulk of Stieglitz's letters were written at his summer place on Lake George, since there he had both the need and the time to correspond with distant friends. He also had time to read, and his letters are studded with references to books. He especially liked to discuss books with Seligmann, who was a versatile man of letters and the first critic here to take D. H. Lawrence seriously. Since Stieglitz's letters present his immediate reactions to literature, unclouded by time, I regard this source as especially reliable.

A survey of the books that Stieglitz mentioned in his letters to literary friends during the 1920's and the 1930's discloses definite categories within his seemingly random reading. A significant number that he read were written, recommended, or presented by people he knew. Another group comprised current releases, especially fiction, from certain publishing houses. Volumes left behind by guests at Lake George and subsequently turned up by the host composed a third category. Finally, Stieglitz was a lifelong lover of horse racing, and he indulged this penchant by reading the lives of famous trainers and jockeys, books about thoroughbreds, and The London Sportsman, the journal of the English turf.

This last category has limited importance in the present study, but it serves to remind one of a sometimes overlooked facet of Stieglitz's personality, that of sportsmanship. In a letter to Paul Rosenfeld, he said that his passion for fair play ("the true Sportsman's real test") exceeded even his passion for photography; and in one to Hart Crane he scored Waldo Frank and other so-called artists because they did not "play the game" openly and fairly, and thus were not "good sports."[39] If Nietzsche was accurate in his tripartite classification of humanity (sportsman, scientist, and artist), then Stieglitz was a universal man, for his character embraced all three types.

The most important literary consequence of Stieglitz's fondness for horses was that it enlarged the common ground between him and Sherwood Anderson. "We have together the love of horses," Anderson observed

to Stieglitz at the height of their friendship.[40] But
his rapport with the photographer was far more intense
than the casual feeling of fellow enthusiasts, so he
qualified his statement by adding that the love of
horses would not suffice: "The horse is the horse and
we are men."[41]

The interest in horses shared by Stieglitz and
Anderson involved them in a striking coincidence: both
men chose the gelded horse to symbolize what they saw
as America's impotency, and in both instances the symbol
had its inception during a visit to Paris. Stieglitz
recalled: "In Paris I once saw two teams of black
stallions pulling wagons. . . . In New York such a
thing would not be permitted. All the horses in the
city are geldings."[42] Stieglitz's feelings eventually
found form in his satiric Spiritual America (1923), a
photograph in which a gelding's castrated loins are
intended to emblematize the nation's spiritual steril-
ity.

Anderson noticed the gelding-stallion contrast
during his trip to Europe in 1921 and recorded these
musings on the subject in his autobiography three years
later: "The French teamsters did not make geldings of
their horses. Magnificent stallions passed drawing
dust carts. Why did Americans unman stallions while
the French did not?"[43]

Like Stieglitz, Anderson saw the alteration of
horses as an index to the differences between Europeans
and Americans, but his subsequent symbolism is not as
deft.[44] When a female character in Dark Laughter (1925)
notices, among other fascinatingly erotic details of
Parisian life, "stallions hitched to dust-carts and
trumpeting to mares," the reader does not need Sigmund
Freud to tell him that the woman is suffering from
sexual repression--a repression she finally relieves
(anticipating Lady Chatterley) in the arms of her
gardener.

Nothing in the available evidence suggests that
either Stieglitz or Anderson influenced the other in
discovering the gelding-stallion symbol. What we have
here instead is another example of the many ideas

and attitudes which Stieglitz and Anderson shared but which they evolved independently. One might even view the whole matter as an example of synchronicity, which Jung defines as "the simultaneous occurrence of two meaningfully but not causally connected events."

Among the books that Stieglitz chanced upon in the house on Lake George was Tertium Organum. This 1920 treatise by Russian mystic P. D. Ouspensky has been solidly identified as a source of Hart Crane's meta-physics.[45] Crane began visiting the Lake George retreat as early as 1923, three years before Stieglitz found the volume. It had almost certainly been left behind by the poet, intentionally or otherwise. But Stieglitz unfortunately neglected to mention to his correspondent what, if anything, he found of interest in Ouspensky.

Concerning another item of his random reading, Stieglitz did describe his reaction. In the summer of 1920 he wrote to Herbert J. Seligmann:

> Am reading Madame Bovary aloud to
> Georgia!--Just happened to pick it
> up--I read it years ago. It reads
> differently to me now. Originally
> read it in French. Was not ready at
> that time to get all the wonder of
> the workmanship & all that signifies
> to me.[46]

In the fall he told Paul Rosenfeld that he had finished reading the novel to O'Keeffe and that it was "cleancut." Once again we see the devotion to crafts-manship that Sherwood Anderson was so voluble about. Stieglitz no doubt sensed in Flaubert's striving for le mot juste an analogue of his own quest for the perfect negative. He also must have appreciated the novel's anatomy of a mésalliance; at the time of the reading, his own marriage was crumbling, and he and O'Keeffe had become lovers.

The remaining categories, books written by friends and seasonal releases, can be discussed together. Naturally he was diligent in following the publications of intimates like Anderson, Crane, Frank, and Rosenfeld.

And when he came upon something of value, even if not
written by someone he knew, Stieglitz bolstered the
book's public reception by purchasing dozens of copies
and giving them to influential readers and critics.
Gratitude for such free-lance promotion, plus the gen-
eral esteem in which his opinion was held, explains why
so many of the new editions he mentioned in his letters
came from a few houses such as Boni & Liveright, the
publishers of Anderson, Crane, and Frank.

Taken altogether, Stieglitz's reading represents
an impressive performance by someone not directly con-
cerned with the world of letters. In addition to keep-
ing up with his friends' new titles and the yearly
releases, he managed to diversify his reading to a
remarkable extent. Fiction, especially novels, was
clearly the most abundant category. But his combined
fare also included philosophy (Spengler, Keyserling,
William James, Santayana), literary criticism (Brooks,
Mumford, Bourne, Symons), art and aesthetics (Faure),
science (Whitehead), the classics (Goethe, Shakespeare,
Cervantes, Rabelais, Hawthorne)--plus some history,
biography, and psychology.

Modern poetry, other than Hart Crane's, interested
him the least. Although he was personally acquainted
with Ezra Pound and Carl Sandburg, he evidenced no
particular interest in their verse. He saw Rilke in
Paris in 1911, when the poet was still Rodin's secre-
tary, but at that time he did not know who the man was.
An unnamed girl moved him to read a few pages of
Robinson Jeffers but he left no record of his impres-
sion of the poet--or the girl.

Ever the foe of puritanism, Stieglitz gravitated
toward the works whose unconventional vigor offended
the public guardians of morality. He read Ulysses at a
time when copies still had to be smuggled into the
United States. D. H. Lawrence personally sent him a
copy of Lady Chatterley's Lover. Rekindling his early
ardor for Zola, Stieglitz read Nana when the American
public still thought it was pornography. Outlawed
Oscar Wilde had delighted Stieglitz in the days before
World War I when Camera Work had embellished its pages
with the aphorisms of "Sebastian Melmoth," and so it

must have been with a twinge of auld lang syne that he read the 1921 edition of Wilde's Portrait of Mr. W. H., a fictionalized theory of Shakespeare's sonnets in which the public detected "unwholesome" overtones.

Victims of the bluenoses found a ready partisan in Stieglitz. Fiercely opposed to any trammels on the artist, the photographer especially detested censorship, and he was furious when the New York Society for the Suppression of Vice (led by the infamous Anthony Comstock) caused the arrest of Guido Bruno for selling copies of a little magazine (the Chap-Book) containing what the society considered a dirty story, in this case Alfred Kreymborg's "Edna, the Girl of the Street." Both the author and the bookseller were friends of Stieglitz and frequent visitors to his 291 gallery. Outraged equally by the arrest and by the public's acceptance of censorship, Stieglitz fired off a letter to Bruno expressing his revulsion at the very idea of a "Comstockian Society" and attributing the rise of such institutions to the "stupidity of people at large." Bruno, who rather enjoyed all the notoriety, promptly printed the letter in his own little magazine.[47] Kreymborg, the cause of it all, shrugged off the whole affair, at least in retrospect, as an instance of Bruno's "lurid propaganda."[48]

Of the proscribed authors supported by Stieglitz, D. H. Lawrence was far and away his favorite. According to Herbert J. Seligmann, himself an early Lawrence scholar, Stieglitz positively venerated Lady Chatterley's Lover: "Stieglitz said he felt the book was one of the grandest that had ever been written, a sort of Bible, on a par with Goethe and Shakespeare."[49] Stieglitz had no higher praise to give Lawrence than this enshrinement beside his beloved Goethe.

Stieglitz's relationship with Lawrence began as early as 1923, when he read Studies in Classic American Literature and immediately posted his compliments to the author. A surprised Lawrence replied: "I expected abuse, & I get, for the very first word, a real generous appreciation that I myself can appreciate."[50] Later Stieglitz admitted that he had some doubts about the accuracy of Lawrence's critical strafings, but, as with Waldo Frank, he respected the critic's premises.

"I enjoyed what he wrote [in the Studies]," Stieglitz admitted to Sherwood Anderson, "even tho' much of it might be all off the track."[51]

Stieglitz also mentioned reading Lawrence's collaborative The Boy in the Bush, and in 1926 he purchased first editions of The Rainbow, Amores, and Kangaroo.[52] Discussing Havelock Ellis's The Dance of Life with Paul Rosenfeld, Stieglitz said that he wished Ellis and Lawrence could be combined "to satisfy the craving in us."[53]

Encouraged by Stieglitz's ardent appreciation of Lady Chatterley's Lover, Lawrence began discussing with his American admirer the possibility of exhibiting his own and Dorothy Brett's paintings in New York, preferably at Stieglitz's Intimate Gallery. But both men had misgivings about an American show for Lawrence at that disturbed time. Finally the "stupid fuss," as the author called it, over Lady Chatterley's Lover, combined with his failing health, caused Lawrence to cancel the projected New York exhibition.[54]

I began this discussion of Stieglitz's reading by pointing out that he turned to books primarily for the confirmation of experience rather than for the discovery of ideas. Consequently, to interpret his reading one must understand beforehand his "mechanism," and any study of the relationship between his principles and the books he read is likely to reveal not chains of cause and effect but series of parallels. The abundance of such parallels suggests what a present-day scientist calls "seriality"; that is, "the universal hanging-together of things, their embeddedness in a universal matrix."[55] Given his sense of fundamental laws, Stieglitz would no doubt affirm such cosmic cohesiveness.

Occasionally Stieglitz encountered a book so vividly written that it focused his own intuitions and encouraged him to apply them in some immediate way. That happened in the summer of 1924 when Paul Rosenfeld gave the photographer a copy of Count Hermann Alexander Keyserling's Das Reisetagebuch eines Philosophen. After reading the German philosopher's "travel diary," Stieglitz declared to Sherwood Anderson that the book

was "entertaining . . . very enlightening . . . [and] stimulating."[56] The treatise emphasizes the merits of empathic appreciation, the validity of intuitions, the primacy of life, and the reality of spirit. No wonder Stieglitz liked it; the principal ideas were all hallmarks of his own Weltanschauung, as indeed Rosenfeld must have known when he gave him the book.

Stieglitz did more than applaud Keyserling's method. When Rosenfeld's next book appeared, Stieglitz modeled his critical approach explicitly after the German philosopher's:

> I'm not reading [Port of New York] to "criticise." I'm reading with all of me--& let whatever happens happen.--Whatever is true will then register. . . . Keyserling puts his finger on many things which help one to one's own clarity.[57]

Both Keyserling and Stieglitz evidently agreed with Coleridge that sympathetic reading requires the "willing suspension of disbelief for the moment." And it was Keyserling who, ironically, supplied the reasoned argument for this brief revival of Romantic anti-intellectualism and who thereby confirmed the intuitive, impressionistic bias of both Stieglitz's and Rosenfeld's criticism.

The photographer also acknowledged a certain similarity between himself and Keyserling in the methods they used to comprehend objective reality. Although the demands of artistic freedom seemed to condone relativism, Stieglitz could not be content with saying that the objective world is only what each person thinks it is. And since both photography and modern art tend to be nominalistic, Stieglitz was often at pains to universalize his concept of reality and avoid the pitfall of solipsism.

As early as 1914, in an attempt to encompass the meaning of all his gallery stood for, Stieglitz struck upon the device of soliciting as many opinions as possible on the topic question "What is 291?" and printing the collected impressions in a single issue of

<u>Camera Work</u>. The idea of a symposium is at least as old as the Greeks, but Stieglitz saw it as a mechanism for metaphysical apprehension. Years afterward he cited the "What is 291?" issue of <u>Camera Work</u> (no. 47, July 1914) as an example of his theory that subjective impressions are the basic stuff of reality. Looking out a window of The Intimate Gallery at some new construction along Park Avenue, Stieglitz elaborated:

> Suppose some one was looking out of
> the window and was asked what he saw.
> He might say that the sun is shining
> and building is going on. If another
> person were asked, he might--he
> would--tell of something else. And
> so with fifty people--or fifty million
> people--each one would see and tell
> something different. Would any one
> of them or all of them tell "It"--
> in the sense of what was actually
> going on. No. But the "It" is the
> thing Americans are looking for. I
> maintain there is no "It." What is
> going on out there is the sum of
> what all people see who look through
> the window, plus what all the possible
> people see who might look through it
> in the future--plus something going
> on that we don't know anything about.[58]

In his attempt to find a more universal frame of reference than that available to the unaided ego, Stieglitz moved toward a kind of <u>consensus gentium</u>. Objective reality is not only what each person sees but what all persons might see; thus the artist's individual license in the field is controlled by empirical corroboration in the gallery. The x factor in Stieglitz's formulation, "something going on that we don't know anything about," seems rather a hedge; but, assuming that he was referring to spirit, the statement agrees with his idea that spirit is something indescribable but nonetheless operative, as Santayana said of beauty in another context.

Keyserling entered the deliberation on the nature of "It" when someone compared the "What is 291?"

issue of <u>Camera Work</u> with <u>The Book of Marriage</u>, a symposium that the count had edited. Herbert J. Seligmann describes the photographer's reponse: "Stieglitz said that the collaboration of a number of writers on this subject [marriage] was akin to his idea, except that Von Keyserling was apparently ready to crystallize his own views, whereas he, Stieglitz, was not."[59] Protean to the end, Stieglitz never did consolidate or structure his views into a unified philosophy; but ultimately his friends and followers employed the symposium technique in their attempt to capture the essential nature of the photographer himself. They collected facts and impressions from twenty-five sources and assembled the lot into a remarkable "collective portrait" called <u>America and Alfred Stieglitz</u>.[60]

Although Stieglitz rejected the purely materialistic concept of reality that he believed prevailed among Americans, he was not prepared to go to the extreme of transcendentalism and agree with Emerson that the universe is an idea in the mind of God. His efforts to reach reality were hardly more advanced than those of the eighteenth-century empiricists, although the experimental theory did provide a rationale for the operation of his "laboratory" galleries and the exhibitions of his photographs, activities that his pessimism might otherwise have disabled. His most profound grasp of reality, however, was achieved not through quantitative accumulation but through an ideal qualitative synthesis--his renowned doctrine of the equivalent. Touched on earlier, this synthesis and its place in his aesthetics are the topics of the next and final chapter.

[1] AS to Waldo Frank, Aug. 28, 1926.

[2] Alfred Stieglitz, "Thoroughly Unprepared," Twice a Year, nos. 10-11 (Fall-Winter 1943), pp. 252-53.

[3] Ibid., p. 253. Herbert J. Seligmann transcribed this anecdote with slightly different details in AS Talking, pp. 82-83. In Seligmann's version Stieglitz also credits the "Russian writers of fiction" as the "equivalent" of philosophy.

[4] Dorothy Norman, "From the Writings and Conversations of Alfred Stieglitz," Twice a Year, no. 1 (Fall-Winter 1938), p. 100; Seligmann, AS Talking, pp. 35, 44-45, 85.

[5] Alfred Stieglitz, "Thoroughly Unprepared," Twice a Year, nos. 10-11 (Fall-Winter 1943), p. 252. Paul Rosenfeld describes Stieglitz's horse-racing game (modified parcheesi) in the opening paragraph of "The Boy in the Dark Room," in Frank, America & AS, p. 59. It was this passage that triggered the dispute with Stieglitz over Rosenfeld's word courser mentioned earlier.

[6] Ibid.

[7] Norman, AS: Intro., p. 48

[8] Seligmann, AS Talking, p. 64.

[9] Stieglitz's commonplace book reposes among his papers at the Beinecke Rare Book and Manuscript Library. It has 143 numbered entries, plus some without numbers, all transcribed in Stieglitz's bold calligraphy. Some of the entries are in English, many are in German, with

9 (cont.) no consistent regard for the nationality of the original. We find, for example, Polonius' advice to Laertes written in German, but this merely reminds us that Stieglitz was then studying in Germany. The quotations in the commonplace book are usually followed by the author's name, but specific works are never mentioned.

10 I have silently Englished the German quotations and paraphrased wherever it seemed advisable. The italics are sometimes Stieglitz's, sometimes the original author's.

11 Seligmann, AS Talking, pp. 51, 101.

12 From a diary entry dated Feb. 16, 1957, in the unpublished biography of Herbert J. Seligmann.

13 Frank, America & AS, pp. 59-88. Stieglitz himself edited the manuscript of this profile before publication; the facts therein must have met with his approval.

14 Ibid., p. 66. Rosenfeld does not mention whether or not Stieglitz was familiar with Zola's Le roman expérimental.

15 Ibid.

16 Ibid. Edward Steichen said that upon Stieglitz's return home from Germany, "he discovered the adventure stories of Jack London, devouring each one as it appeared"; quoted in Joseph Shiffman, "The Alienation of the Artist: Alfred Stieglitz," American Quarterly, 3 (1951), 255. Stieglitz himself was silent about Jack London.

17 Alfred Stieglitz, "Thoroughly Unprepared," Twice a Year, nos. 10-11 (Fall-Winter 1943), p. 129.

18 Alfred Stieglitz, "Three Parables and a Happening," _Twice a Year_, nos. 8-9 (Spring-Summer, Fall-Winter 1942), p. 129.

19 Ibid.

20 Ibid., p. 121.

21 Benedetto Croce, _Goethe_, trans. Emily Anderson (New York: Knopf, 1923), pp. 63, 68.

22 Ibid., p. 74.

23 See especially Neil Leonard, "Alfred Stieglitz and Realism," _Art Quarterly_, 29 (1966), 277-86.

24 Theodore Dreiser, "Life, Art and America," _Seven Arts_, 1, no. 4 (Feb. 1917), 363-89.

25 Theodore Dreiser to AS, Feb. 7, 1917.

26 AS to Waldo Frank, Feb. 22, 1938.

27 AS to Sherwood Anderson, Aug. 15, 1923.

28 Ibid.

29 Norman, _AS: Intro._, p. 9.

30 Both quotations are from Norman, _AS: Intro._, p. [12].

31 Stieglitz's speaking in parables also suggests a little myth-making on his part. Carl Zigrosser says that Stieglitz wished to create a legend by means of the direct impress of his words on the minds of those around him (_The Artist in America: Twenty-four Close-ups of Contemporary Printmakers_ [New York: Knopf, 1942], p. 116).

32 Alfred Stieglitz, "Thoroughly Unprepared," Twice a Year, nos. 10-11 (Fall-Winter 1943), pp. 246-47.

33 Alfred Stieglitz, "Four Happenings," Twice a Year, nos. 8-9 (Spring-Summer, Fall-Winter 1942), pp. 167-70.

34 The guardian of the wine symbol undoubtedly owes something to the fact that young Stieglitz was the custodian of his father's wine cellar; see Seligmann, AS Talking, pp. 9-10, and AS to Sherwood Anderson, Oct. 4, 1927.

35 Paul Rosenfeld recalled that the familiars of the 291 gallery sometimes stood around as if waiting for Jesus to work a miracle.

36 Alfred Stieglitz, "Four Happenings," Twice a Year, nos. 8-9 (Spring-Summer, Fall-Winter 1942), p. 121.

37 Dorothy Norman, "From the Writings and Conversations of Alfred Stieglitz," Twice a Year, no. 1 (Fall-Winter 1938), p. 110.

38 William Carlos Williams, "What of Alfred Stieglitz," unpublished essay dated Oct. 16, 1946; in the Beinecke Rare Book and Manuscript Library.

39 AS to Paul Rosenfeld, Dec. 15, 1920; AS to Hart Crane, Oct. 27, 1923.

40 Sherwood Anderson to AS, [Aug. 6, 1923]; in Letters of SA, p. 106.

41 Ibid.

42 Norman, AS: Intro., p. 23.

43 Anderson, A Story Teller's Story, p. 388.

[44] Anderson's gelding fixation and his love of horses are targets of Hemingway's satire in _The Torrents of Spring_ (1926).

[45] Brom Weber, _Hart Crane: A Biographical and Critical Study_ (New York: Bodley, 1948), pp. 157 ff.

[46] AS to Herbert J. Seligmann, July 29, 1920.

[47] _Bruno's_, 1, no. 1 (Jan. 8, 1917), 8.

[48] Alfred Kreymborg, _Troubadour: An American Biography_ (New York: Boni & Liveright, 1925), pp. 78, 161.

[49] Seligmann, _AS Talking_, p. 135.

[50] D. H. Lawrence to AS, Sept. 17, 1923.

[51] AS to Sherwood Anderson, June 10, 1925.

[52] Seligmann, _AS Talking_, p. 13

[53] AS to Paul Rosenfeld, Nov. 20, 1923.

[54] D. H. Lawrence to AS, Aug. 15, 1928; Sept. 1, 1928; and Sept. 12, 1928.

[55] Quoted in _Newsweek_, Aug. 14, 1972, p. 82B.

[56] AS to Sherwood Anderson, June 18, 1924. Stieglitz of course read German fluently.

[57] AS to Paul Rosenfeld, July 12, 1924.

[58] Seligmann, _AS Talking_, p. 83.

[59] Ibid.

[60] A similar attempt to grasp reality by means of accumulated impressions can be seen in Stieglitz's conglomerate portrait of Georgia O'Keeffe, which consists of hundreds of separate photographs. For a selection of them, see <u>Georgia O'Keeffe: A Portrait by Alfred Stieglitz</u> (New York: Viking, 1979).

CHAPTER 7

THE DARING PATHWAY

Stieglitz's Aesthetics

The surest road to a photographer's aesthetics is
through his photographs, and so a brief overview of
Stieglitz's career is in order before we proceed to
detailed analyses of his work and his theories. His
early pictures display great charm and visual sensi-
tivity, but they also reveal considerable influence by
picturesque painting. With its classical qualities of
simplicity, harmony, and pastoral serenity, Stieglitz's
Harvesting, Black Forest, Germany (1894) is virtually
a reincarnation of Millet's The Gleaners (ca. 1857).
In his determination to raise photography to the level
of art, he even transformed some of his prints into
imitation mezzotints during his Pictorial Photography
phase.[1]

Two decisions led to the triumphant emergence of
his mature work: his acceptance of "straight" (that is,
unmanipulated) photography and his recognition that the
motive power of all true art is acute emotion. By
restricting himself finally to the basic photographic
process, he underscored the integrity of the medium;
and by identifying the key role of emotion in art, he
laid the foundation of his own aesthetics. We see the
watershed in his photographs. After he returned to
New York from Germany in 1890, his intense unhappiness
in that city catalyzed a series of epochal pictures,
some of which I will discuss further. When, four years
later, he went back to Europe for a summer, his pic-
tures reverted to their earlier placidity, the neces-
sary spark being absent. Fortunately he spent most of
his life in New York.

Stieglitz's first photographic impulses, then, can
be termed technical and blandly pictorial; and his
youthful conception of beauty leaned heavily upon con-
ventional painterly canons. In his first published
essay on Pictorial Photography, the best he can do in
defining the "artistic" class of photographers is to
say that they bring to photography the "feeling and
inspiration of the artist, to which is added afterward
the purely technical knowledge." Similarly, a "truly
artistic" photograph is the "result of an artistic

113

instinct coupled with years of labor."[2] How the art-
ist's feeling, inspiration, and instinct differ from
those of the layman, Stieglitz neglects to say, being
preoccupied here with justifying photography as an art,
not with defining art itself. What is particularly
notable in his comments is the unwavering assumption
that emotion precedes form. This principle is the cor-
nerstone of his masterworks; it is also the bedrock
conviction that he shared with the literary expression-
ists, as we shall see.

In his second article on Pictorial Photography,
Stieglitz again skirts crucial aesthetic problems and
merely says in passing that the aim of the artist is
"to produce with the means at hand that which seems to
him beautiful."[3] Stieglitz here is arguing for complete
freedom of technique, but the statement also implies
that beauty is whatever the artist conceives it to be.
Such aesthetic tolerance and flexibility came to the
fore when Stieglitz later began to champion avant-garde
art. The article in question is also a manifesto of
the Photo-Secession, a movement which Stieglitz, its
originator, says is "doing everything possible still
further to free the art [of photography] from the tram-
mels of conventionality, and to encourage greater
individuality."[4]

As leader of the Photo-Secession, Stieglitz freed
himself for all time from the "trammels of convention-
ality," and he soon abandoned the technical experimen-
tation into which the photography-is-art struggle had
lured him, probably realizing that innovation for the
purpose of imitation is the worst kind of conventional-
ity and also a violation of photography's integrity as
an independent medium of expression.

But we must go back to the 1890's and Stieglitz's
discovery of the equivalent, for it is the key to his
photography and to his aesthetics. He explained its
general principle thus: "Shapes, as such, mean nothing
to me, unless I happen to be feeling something within,
of which an equivalent appears, in outer form."[5] In
other words, there is a causal connection between sub-
jective emotion and objective appearance.

Stieglitz's equivalent bears an obvious resem-
blance to T. S. Eliot's famed "objective correlative,"
but so far as I can tell there is no bond between the
two theories other than coincidental similarity. In

some respects the two are opposites. The objective
correlative mainly concerns the reader's emotional
response; the equivalent looks to the artist's feelings
as catalyst. Stieglitz concentrated on the making of
the art object; Eliot, on its effects.

Stieglitz's explanation of the equivalent makes it
sound deliberately preconceived. In actuality its dis-
covery was empirical, almost contingent. He later uni-
versalized his doctrine and said, "All art is but . . .
an equivalent of the artist's most profound experience
of life," and, "all of my photographs are equivalents
of my basic philosophy of life."[6] But the original
equivalent involved the accidental but fruitful con-
junction of an identifiable emotion with concrete
objects or forms in nature, the result being a specific
photograph. The occasion was the blizzard that struck
New York in February of 1893. At that time Stieglitz
was still suffering from "an intense longing for
Europe," and in New York, his home, he was "overwhelmed
by a sense of emptiness and restraint . . . [and] felt
bewildered and lonely." To escape this feeling of
alienation, as it is now called, he went out into the
blizzard with one of the then new hand-held cameras.
Seeing the horse-drawn coaches struggling through the
snowy desert of Fifth Avenue, he beheld the very
gestalt of isolation. "Could what I felt be photo-
graphed?" he wondered. It could--and the result was
his celebrated Winter, Fifth Avenue.[7]

The next day the still estranged photographer came
upon a horsecar driver holding a bucket of water for
his steaming animals. "I felt how fortunate the horses
were," Stieglitz remembered, "to have at least a human
being to give them the water they needed. What made me
see the watering of the horses as I did was my own
loneliness." Again his emotion in effect energized the
act of seeing. In a state of happiness he probably
would not have noticed the scene that here transfixed
him. Again he decided to try to photograph his feeling
of loneliness--and the result was another classic of
American photography, The Terminal.

When I first read Stieglitz's explanation of the
genesis of Winter, Fifth Avenue and The Terminal, it
seemed simply to describe another instance of art used
to express emotion, and in my first discussions of his
work I used the term expressionistic to classify his
special kind of photography. But the word, I quickly

115

learned, is too ambiguous. Moreover, I discovered another aesthetic system that more exactly serves his theory of the equivalent, as we shall see at the end of this study. Expressionism, nevertheless, has some value as an entry into Stieglitz's aesthetics. Indeed one highly reputed art critic has applied the term not only to Stieglitz but to the whole 291 group. In his introduction to modern art, Sheldon Cheney says:

> Expressionism in America has a history back to the first decade of the century.
>
> The date might almost be fixed by reference to the calendar of exhibitions at the Photo-Secession Gallery--the famous "291"--in New York. And the artist who is likely to be named oftenest . . . when the history of the movement is written, is Alfred Stieglitz. He knows better, instinctively, what <u>expression</u> is than any other American.[8]

It may seem that this statement, if true, contradicts what I said earlier about the impressionistic quality of Stieglitz's response to his friends' literary productions. The photographer himself would not have worried about this seeming discrepancy, for he believed that contradictions are inevitable in anyone who is "truly alive" and that "literalness is contrary to life itself."[9] Actually, however, there is no inconsistency here. Stieglitz's interpretations and criticisms were in fact impressionistic. Encouraged by Paul Rosenfeld, who in turn invoked Hermann Keyserling's philosophy of appreciation, Stieglitz consciously adopted a passively receptive stance in his reading. He opened the doors of his consciousness to whatever would flow in. If nothing did, then the fault lay with the book, not with the reader. When functioning as an art critic, Stieglitz felt that he could do no more than to give the work in question every opportunity to register its "livingness" on his empathic sensibility.

Thus I see Stieglitz as basically an impressionistic <u>critic</u>. As an <u>artist</u>, however, he took the opposite tack, and his photographs and his statements about them are perfectly congruent with Cheney's assertion that "emotional intensification is at the very

heart of Expressionism."[10] As the photographer himself
put it, in a letter to a friend in 1917, "It is the
intensity of feeling expressed which lives. . . .
Technique is a dead thing, no matter how masterly it
may be in itself."[11] In another place he recalled the
talk he gave during a forum on modern art, also in
1917:

> I related about my _aloneness_ in the
> beginning and how through photogra-
> phy I found the Car Horses as friends
> . . . and how I attempted to express
> my feelings about life through photo-
> graphing what I saw and felt . . .
> and how gradually the passion for
> photography led me into the examina-
> tion of painting and all other modes
> of expression.[12]

What concerns us here is precisely Stieglitz's
relation to one of those other modes of expression,
that is, to literature. Joseph Warren Beach offers an
outline of expressionism that is as applicable to
literary as to visual art:

> Expressionism stands, strictly speak-
> ing, in opposition to impressionism.
> Impressionism is, in the main, a
> variety of realism. It undertakes,
> by means of a special technique, to
> give a more precise impression of
> the look of the object studied. It
> is quite as literal as the earlier
> manner of rendering the object,
> though it has a different system of
> notation. Expressionism pretends,
> on the contrary, not to give an
> impression of the look of the object
> but to express its meaning or essence.
> It eschews the letter in favor of
> whatever symbol is best suited to
> suggest that interior meaning. It
> is licensed, at will, to neglect
> perspective and to make use of any
> dimension, beyond the three familiar
> ones, which will help to "locate"
> more exactly the interior meaning it
> is concerned with.[13]

117

Beach unfortunately neglects the importance of emotion in expressionism. As Stieglitz made clear in his explanation of the equivalent, it is feeling and feeling alone that gives objects their meaning. In itself an object is neutral. Emotion, not sight, reveals shapes and in so doing imbues the Stieglitzian world with essence. Naturally we are always "feeling something within," and so objects are never totally without meaning. What Stieglitz might have gone on to say is that the significance of the outside world exists in proportion to the intensity of one's emotional state, to the degree of one's psychic charge.

The expressionist is himself like a camera in that he uses a previously sensitized consciousness, his "film," in order to record the forms introduced by his eyes, the "lens." The sensitive "emulsion" of the expressionist's film is supplied by emotions--the more acute the emotion, the greater the seeing ability of the artist/camera. For the impressionist, on the other hand, such sensitizing before the event is unnecessary; the images themselves contain whatever energy is needed to engrave their forms on his tabula rasa.

The crucial difference here is whether one considers the a priori consciousness to be active (as in expressionism) or passive (as in impressionism). Hart Crane had this distinction in mind when he wrote:

> If the essences of things were in
> their mass and bulk [and were there-
> fore accessible to the senses] we
> should not need the clairvoyance of
> Stieglitz's photography to arrest
> them for examination and apprecia-
> tion. But they are suspended on
> the invisible dimension [of time]
> whose vibrance has been denied the
> human eye at all times save in
> the intuition of ecstasy.[14]

This "intuition of ecstasy" is Crane's version of the sensitized consciousness, a creative condition as prerequisite to his poetry as to Stieglitz's photographs.

Another way to think about the impressionist-expressionist dichotomy is to examine the direction of the flow of meaning between subject and object. Such an ontological approach implies that aesthetics is

ultimately founded on metaphysics or even on psychology, and so I believe it to be, even though aestheticians such as Benedetto Croce have insisted on the autonomy of their discipline. In either system--impressionism or expressionism--the subject, the ego, stands at the center of the world of objects, surrounded by the Not Me, or Nature, to use Emersonian terms. With impressionism the objective world impinges centripetally on the ego, giving it meaning and thus existence. With expressionism the reverse is true: the ego emanates itself like a beacon, giving meaning and thereby reality to surrounding objects.

The media of transference also differ: impressions are sensory, at least initially, while expressions are exclusively emotional and intuitional. The impressionistic mode of art therefore tends to be descriptive and mimetic (the mirror rather than the lamp, to enlist M. H. Abrams' well-known metaphors), and its method of development is mainly accretionary. Expressionism, on the other hand, generally employs the lyrical mode coupled with organic development. Finally, to round out these dualities, impressionism, being strongly mimetic, found favor in both the classic and the realistic periods of art (though of course the word itself has modern associations), while the expressionistic artist came into his own with the advent of Romanticism.[15]

Applying these distinctions to Stieglitz, we see that his theory of the equivalent is congruent with expressionism in every respect, especially in its assumption that meaning results when the artist's feelings (such as loneliness and "heartache") radiate outward to the world of objects (such as car horses and blizzards). Awareness of the expressionistic nature of Stieglitz's photography reverberated through his literary acquaintances. The like-minded marshaled themselves at his side, while those of different aesthetic persuasions (the impressionists, including the realists) found no congeniality in the 291 gallery or in the other Stieglitzian places.

Of the writers who gravitated to Stieglitz, the one most deeply involved with expressionism was undoubtedly Waldo Frank; and Joseph Warren Beach, in the study quoted earlier, rightly analyzes Rahab as an expressionistic novel, although other critics have mistakenly regarded it as a work of impressionism.[16] Frank

himself preferred the term "lyric novel" to describe
Rahab, City Block, Holiday, and Chalk Face. This genre
is explained in William Bittner's full-length study of
Frank's fiction: "The lyric novel, like the [lyric]
poem, is an emotional rather than a rational experience,
and unlike realistic fiction, its esthetic does not
rely on reflection of life, but makes a more direct
contribution to life." In The Re-discovery of America
Frank calls that contribution the "apocalyptic method,"
which he defines as the "direct re-creation of a formal
world from the stuffs within us." But Frank's method
is nothing more nor less than expressionism, and with
perfect justice he cites Stieglitz as one of the handful
of contemporary artists who possessed the "apocalyptic
vision."

Other expressionists among Stieglitz's literary
friends were Sherwood Anderson, Hart Crane, Jean Toomer,
and D. H. Lawrence. Anderson's expressionism found its
chief outlet in his poetry (the "Chants" and the
"Testaments" and such things as "New Orleans: A Prose
Poem in the Expressionist Manner"), but it also carried
over into his fiction generally. "You see," he once
said, "I have the belief that, in this matter of form,
it is largely a matter of depth of feeling."[17] If
expressionism could be reduced to a maxim, it would be:
"Form follows feeling."

In the same vein Anderson distinguished Dark
Laughter from realistic novels by calling it a
"fantasy," explaining, "No realism in it. An attempt
to catch the spirit of things now."[18] The author's
comments here and in A Story Teller's Story follow
Beach's outline of expressionism almost verbatim: "These
notes [writes Anderson] make no pretense of being a
record of fact. . . . It is my aim to be true to the
essence of things" (p. 100). And for stark expression-
ism, consider Anderson's advice to his son John about
painting: "The object drawn doesn't matter so much.
It's what you feel about it [that counts]."[19]

Unquestionably Stieglitz strengthened Anderson's
decision to cultivate the "emotional response to life."
The novelist, however, had sense enough to deride such
a response when it was merely a pose. Thus in one of
Anderson's rare attempts at satire, a piece called "The
Triumph of a Modern," a self-styled critic says of a
certain portrait, "The arm of the woman is not felt.
In painting one should feel the arm of a woman."

The expressionistic bent of Hart Crane should be self-evident to any reader of The Bridge. Even friendly critic Gorham Munson thought his poetry "excessively subjective."[20] Crane justified this quality by saying that "in the absolute sense the artist identifies himself with life" and that subjectivity in the artist is actually a "purer projection" of self, such as that found to an eminent degree in Stieglitz's photographs.[21]

Jean Toomer's description of his visit to Stieglitz's summer place is an expressionistic memoir by an unabashed man of feeling--a new sentimental journey:

> My first visit to The Hill I was
> soon struck by a feeling that came
> from [Stieglitz] constantly and
> filled the house. . . . Outside snow
> was on the hills. . . . But I felt
> warmth. . . . Feeling, I believe, is
> the center of his life. Whatever he
> does, he does through feeling. . . .
> Whatever he thinks, he thinks with
> feeling. . . . Feeling is being.[22]

This last statement encapsulates the expressionistic ontology: not Descartes' cogito ergo sum but sentio ergo sum--I feel therefore I am.

D. H. Lawrence may appear to be an odd companion for the expressionists, but I include him here because I believe that his Studies in Classic American Literature is the most radically emotional outburst in the history of Anglo-American literary criticism. His concern in those essays is not with recording any kind of objective impressions, but rather with baring his own quite subjective, even idiosyncratic, feelings about certain works and authors. The squibs tossed at "that blue-eyed darling Nathaniel," for example, have scant relevance to Hawthorne or to his writings. Rather they are pot shots in Lawrence's personal war on sexual inhibitions. But despite--or perhaps because of--their emotional extremism, Stieglitz, we recall, wrote a glowing letter of appreciation after reading the essays.

Of those writers who did not seek Stieglitz out, little can be said about their motives that is not mere speculation based on negative evidence. Obviously Stieglitz's confinement to New York forestalled many

contacts, especially those with expatriates such as Ernest Hemingway or regionalists like William Faulkner. The reason why the 291 gallery escaped Henry James's notice is clear enough: it had not yet opened when he made the 1904 tour of this country that resulted in The American Scene. But why, one asks, did William Dean Howells never visit 291, despite his long residence in New York and his abiding interest in painting and photography? Stranger still, Howells' chief dalliance with the photographic metaphor, a work called London Films appeared in 1905, the same year that 291 began a series of outstanding photographic exhibitions. Yet as far as I can tell, he never attended any of them. This question begs further study.

Although still largely speculating, we can assign more probable motives to those writers who knew Stieglitz at one time or another but who subsequently moved out of his field of force. That group had one notable similarity: they were all basically impressionists, a term that here embraces the literary realists. They included Theodore Dreiser, William Carlos Williams, and Gertrude Stein.

I have already discussed the Dreiser-Stieglitz relationship and explained why the seed of that friendship fell on stony ground. As further evidence of Dreiser's impressionistic orientation and therefore his aesthetic antithesis to Stieglitz's method, consider the fact that Eugene Witla, Dreiser's autobiographical alter ego, is not only a painter but also a virtual pattern of the impressionistic artist. In The "Genius" Witla's consciousness is compared explicitly to a tabula rasa: "The summer night with its early rain, its wet trees, its smell of lush, wet, growing things was impressing itself on Eugene as one might impress wet clay with a notable design."[23] Eventually in the novel Witla finds a way to transfer his impressions to paintings such as the one of Fifth Avenue in a snowstorm mentioned earlier in this study. What is significantly absent in Witla is the expressionist's prerequisite; that is, an acute emotion such as Stieglitz's loneliness when he made Winter, Fifth Avenue.

It might be countered that Stieglitz himself sometimes responded to natural beauty in the passively receptive manner of an impressionist. Indeed, his letters of November 1923 celebrate the "feast of beauty" he enjoyed when a "wondrous snowstorm" turned Lake

George into a fantasy land. He photographed, he said, until he nearly collapsed--but, tellingly, no master-piece like The Terminal resulted from his efforts. Why not? What was missing? Precisely the a priori emotion that flowed from young Stieglitz to the car horses. At Lake George he simply responded to natural beauty, as did Eugene Witla. But Stieglitz was not an impressionist. During the Blizzard of '93 his anguish itself supplied the creative power that illuminated the supernal beauty and the reality of the outer world.

William Carlos Williams I regard as an impression-ist in the sense here developed because of the charac-teristic objectivity of his work, especially his Imagist poems. Gorham Munson touched the heart of the issue when he said of Williams: "To see the thing with great intensity of perception, to see it directly, simply, immediately, and without forethought or after-thought, is the unvarying psychological basis for [Williams'] Al Que Quiere and the later books of poems."24

By thus stripping the data of poetry to pure sen-sation, by peeling away both associated ideas and emo-tional connotations (as far as this is possible in language), Williams founded his art as radically on the psychology of John Locke as did the impressionists in general. Together with his reaction against what he saw as metaphysical obfuscation in poetry, Williams, I conclude, ultimately rejected the 291 group as much because of their expressionistic subjectivity as by reason of his aversion to Stieglitz's talking and the alleged mistreatment of Marsden Hartley.

Like Williams, Gertrude Stein was committed to communicating the reality of things-in-themselves. She had no desire to irradiate objects with her own emo-tions in the manner of the expressionists, and even her autobiography was objectively cloaked in the third person. Her famous device of repetition with variation is actually a specialized form of impressionistic nota-tion. She began, like all impressionists, with sensory experience and developed her "portraits" through a process of accretion like coral polyps making a reef. "All my early work," she explains in the Choate Literary Magazine, "was a careful listening to all the people telling their story . . . [and after noting their repetitions] I conceived the idea of building this thing up." Her stripped-down language, she goes on to

say, is an attempt "to get this present immediacy without trying to drag in anything else"--the immediacy, that is, of primary sense data.[25] Stein began with sensation, Stieglitz with emotion. Thus I think it unlikely that she and the photographer could ever have found an aesthetic meeting point, regardless of their mutual admiration for the European modernists.

Of all Stieglitz's literary friends, Paul Rosenfeld was the one avowed impressionist who never turned away from him. We have already seen how enthralled he was by Stieglitz's dynamism, and on more than one occasion he apologized, almost abjectly, for his addiction to impressionistic criticism. Stieglitz, apparently not recognizing the radical objectivity of Rosenfeld's impressionism, kept urging him to be a man of feeling--a remedy that would have turned Rosenfeld into the kind of critic exemplified by Waldo Frank and D. H. Lawrence.

More than once Rosenfeld was chagrined by being unable to match his impressions to Stieglitz's feelings about a photograph. In 1928, for example, Stieglitz sent the critic one of the cloud studies. In his next letter Rosenfeld offered his interpretation, saying that he saw in the print "the something dark and sad in the universe . . . the face of universal tragedy."[26] Stieglitz's reply has disappeared, but it was patently adverse, for Rosenfeld hastened to apologize: "I am quite mortified to hear that my interpretation of the 'sky' you so kindly sent me, was only mediocre."[27] And so in this letter and in a subsequent one (August 8, 1928), Rosenfeld continued to grope for an acceptable interpretation, one, that is, in tune with Stieglitz's feelings.

The problem here was that Rosenfeld regarded the cloud photograph as an object with an independent reality, whereas Stieglitz saw it as the equivalent of his emotion at the moment he made it. Rosenfeld of course knew Stieglitz's theory, but in this instance he faced the task of producing an unprompted reading of the picture with no indication of Stieglitz's feelings at the time he made it. In the end Rosenfeld had to admit that he simply did not know what to look for. The whole incident was probably a test by Stieglitz, and Rosenfeld failed it.

The fundamental subjectivity of the equivalence

theory was again demonstrated by Rosenfeld's reaction to The Steerage. For Stieglitz, we recall, that picture was the equivalent of the "deepest human feeling." Rosenfeld, however, having nothing to derive his impressions from except the objective half of the equivalent, the print itself, saw only "nose-picking men and ape-mothers" in the photograph.[28]

If further evidence of Rosenfeld's natural antipathy for expressionism is needed, it can be found in his admonition to Waldo Frank and to "all of us" to seek "that state of maturity in which artistic energies are turned outward, toward other people. . . . There, and there alone, will we find ourselves doing substantial and constructive work, and contacting reality."[29] Characteristically, the impressionist contacts reality by turning outward, toward external objects, including people, as sources of impressions and therefore of being. Frank, however, wanted to re-create a formal world from the "stuffs" (principally emotions) within himself. But though he criticized Frank's subjectivity, Rosenfeld apparently never found fault with Stieglitz's aesthetics. In his eyes Stieglitz was the only great American artist since Whitman.

Besides confirming the fundamental value of emotion in art, expressionism included two offshoots of special interest to a study of Stieglitz's literary circle: the organic principle and the lyric mode of art. The organic tradition in America can be traced from Stieglitz, Frank Lloyd Wright, and Louis Sullivan, through Whitman, back to Horatio Greenough and Ralph Waldo Emerson. This is not the place for a detailed examination of the tradition, but it would be well at the outset to distinguish the different kinds of organicism: those of place, form, impulse, and means.

Organicism of place looks to the indigenous qualities of an art and especially to the nationality of the artist. Because of his spirit of place, Stieglitz was seen above all as an American, and his photography as a distinctly national phenomenon. With much the same sort of perspective, Sherwood Anderson believed that in A Story Teller's Story he had frankly and openly revealed himself as "the American Man."

Organicism of form emphasizes the growth of the art object according to its own inherent principles, independent of the conscious will of the artist, the

result being a perfect integration of form and content. To call upon Anderson again, he believed that form "grew out of the materials of the tale and the teller's reaction to them."[30] The artist's contribution to the process is thus considered to be entirely a matter of emotional response to the subject matter.

Very like organicism of form is that of impulse. Here the accent is on the inception or motive of the artistic act. Either the impulse grows from some seed within the artist or it flows into him from some super-human source, as in the classical theory of divine inspiration and in Emerson's concept of the "passive Master" in his poem "The Problem."[31] Organicism of form, like that of impulse, encourages the artist to capture by any means at his disposal life's distinctive qualities of growth and flux. Form as a purely static property is to be minimized.

Organicism of means is more limited, but it has a special application to Stieglitz in that, as Harold Rugg said, he used "a mechanical instrument to lay bare the moving life below the surface of organic nature things."[32] I reviewed this aspect of Stieglitz, his subjugation of the machine, in the discussion of the symbolic phase of his career.

By underscoring the emotional response to life, expressionism also fostered the organic ideas that art springs from seeds in the human breast and that its forms should seek to reenact the emotional flux of life. These concepts surfaced repeatedly in Stieglitz's career. In the first issue (July 1897) of Camera Notes (the predecessor of Camera Work), Stieglitz announced his editorial commitment to pictures that are the "development of an organic idea, the evolution of an inward principle."[33] Elsewhere he urged the nourishing of the "life-force" because he believed that true ideal-ism must stem from man's inmost being: "The subconscious, pushing through the conscious, driven by an urge coming from beyond its own knowing, its own control, trying to live in the light, like a seed pushing up through the earth, will alone have roots, can alone be fertile."[34] As a final example of Stieglitz's acknowledgment of the organic impulse in his own work, consider the succinct explanation he gave Hart Crane of the motive behind his cloud pictures: "Life compelled me in the doing--that's all."[35] Stieglitz here takes the role of the "passive Master," who, said Emerson,

"lent his hand / To the vast soul that o'er him planned"--except that Stieglitz, being an absolute idealist, saw the higher power as immanent Life rather than as the transcendent Oversoul of Emerson's philosophy.

Hart Crane undoubtedly understood Stieglitz's orientation toward organicism. After The Bridge was published, the poet confided to his "brother" that one of the difficulties in writing it was finding "the organic form," adding parenthetically that "there is always just one."[36] Not only should the form of The Bridge be organic, thought Crane, but also its contents; to Waldo Frank the poet described his "materials" as the "experience and perceptions of our common race, time, and belief."[37]

Stieglitz's comments on his friends' writings often had a decidedly organic slant. For example, he praised what he called the "feeling of livingness" in Our America.[38] Years later Waldo Frank, its author, returned the compliment by saying, "No man has . . . nurtured as livingly as you my organic sense of life."[39]

Even though his dominant spirit ran counter to expressionism, Paul Rosenfeld occasionally resorted to the organic metaphor. He once complained to Stieglitz that the myriad revisions of Port of New York were interrupting its "flow."[40]

Among the most organically inclined of Stieglitz's literary circle was, not surprisingly, Sherwood Anderson. We have already heard him say that form is an outgrowth of feeling and that the painter should ignore the mere look of the object since his imperative concern is with his own emotions. Once, in a letter to Anderson, Stieglitz described his first vision of the storyteller. He stressed Anderson's "Strength & Beauty," comparing him to a "large simple tree--with strong branches & tender leaves."[41] That organic metaphor must have taken root in Anderson's consciousness, for a few years later he reassured a young friend, "I think it would be a great mistake to waste any time at all thinking of 'form' as form. . . . Form is, of course, content. . . . A tree has bark, leaves, limbs, twigs. . . . The great thing is to let yourself be the tree."[42]

In addition to promoting organic form, expression-

ism also fostered the lyrical tendency of art. And quite logically so. If the main purpose of art is the expression of the artist's emotion, then the most congenial genres are music (especially song), lyric poetry (sometimes lightly disguised as prose), and abstract visual art. These offer the most direct conduits of feeling.

Stieglitz's attraction to the lyric potential of music was pronounced. In his youth he played the piano but gave it up when photography became his chief "passion." Yet he never lost his sense of music's expressiveness. He insisted that any reproductions of his work preserve "that inner singing in the prints."[43] He entitled his semi-abstract sky equivalents Cloud Music and Songs of the Sky, and we recall his delight in Ernest Bloch's praising the musical evocations of the series.

Writers also detected the lyrical quality of Stieglitz's photographs. After describing to Paul Rosenfeld the two prints that Stieglitz had sent him, Sherwood Anderson said, "Both things sing."[44] Earlier I mentioned Stieglitz's applause for Anderson's "voice" in A Story Teller's Story; and, we recall, the author himself wished that there should be music at the bottom of his prose. In another place he mused, "I have . . . dreamed all the time that I might be planting song. You know, something like song seeds in prose."[45] Waldo Frank, the first to salute in print Anderson's "emerging greatness," concluded, after the author had told his last tale, that his stories were "essentially lyrical expression."[46] Later critics have agreed that the "impulse of emotional affirmation" sparks Anderson's tales in the same way it does the lyric poem. But the lyric mode demands an intensity that can be sustained only briefly, and this explains in part why Anderson was consistently more successful in short fiction than in the novel form, and why his best novel, Winesburg, Ohio, is actually a collection of tales.

Waldo Frank came as close as anyone to adapting the novel to meet the needs of the lyric spirit. But today his lyric novels have fallen into oblivion. The spirit of the present age is clearly not that of emotional affirmation. In the 1920's, however, a few souls like Hart Crane shook off the "last shreds of philosophical pessimism" and affirmed the "assimilative capacities, emotion,--and the greatest of all--vision"

128

needed so desperately by the artist of that time and so electrifying realized in the music of the period.[47] Crane emphasized the bond of lyricism between poetry and music; Stieglitz saw a similar kinship in the visual arts. Reviewing an exhibition of modern French paintings, he celebrated the organic "livingness" of the work and praised the artists as "souls unafraid and singing their song within."[48]

Emphasis on lyrical expression in the visual arts led eventually, in fact inevitably, to the abstraction of all recognizable objects, all representational subject matter, from the work itself. Stieglitz's cloud studies were a deliberate step in that direction. One of the prime motives behind the series, Stieglitz explained, was "to show that [his] photographs were not due to subject matter--not to special trees, or faces, or interiors."[49] The photographer was also one of the first Americans to hail abstract painting. As early as 1913 Stieglitz prophesied that, if attained, pictures based on "purely abstract form" would be the "highest and noblest flower of painting."[50]

In his own work, however, Stieglitz was not willing to cut loose from every vestige of objective subject matter. For one thing, his doctrine of the equivalent involved the discovery of objects in the outside world to which the artist could relate his emotions. This implies the coordinate reality of nature and spirit, and Stieglitz was not prepared to enter the solipsistic circle of the abstract expressionist by supplying the shapes as well as the emotions. Another impediment was the inherently mimetic nature of photography. For anyone who wishes absolute control over subject matter, the other visual arts, especially painting, have proven more tractable than photography, given its stubborn, almost ineradicable "realism." Finally, in his heart, Stieglitz simply could not accept the subjective idealism of the abstract expressionists.

Mystified by the cloud prints, Rosenfeld thought that Stieglitz's photography was truly abstract, but the critic's definition included an ambivalent qualification. In Stieglitz's work, said Rosenfeld, one saw "photography projecting feeling purely and almost independently of the instrumentality of the subject matter."[51] But even in the cloud studies the subject matter is only rarely reduced to what Rosenfeld called "mere fabulously delicate markings in black and

129

white."[52] Actually, most of the forms there are recognizably natural; they are not the private hieroglyphs of the abstract expressionist.

At the beginning of this brief look at Stieglitz's relationship to expressionism, I suggested that another system offers a better key to his achievement and his theories. That system is the aesthetics of Benedetto Croce. In Croce's conception of art as an act of intuitional synthesis, we find the most universal base for Stieglitz's equivalent.

Stieglitz himself claimed that the equivalent was a "spontaneous discovery," and there is no evidence to suggest otherwise. His instincts, nevertheless, found support in the theories of Bergson, Maeterlinck, and Santayana--all of whom were overshadowed, in my opinion, by Croce. Quotations from Bergson and Maeterlinck appeared in Camera Work and steepened the idealistic bias of that journal.[53] Maeterlinck came to Stieglitz's attention because of Edward Steichen's enthusiasm for the Belgian playwright; and Camera Work printed, and reprinted, Maeterlinck's letter saluting photography as the medium which, by harnessing the sun and subjugating anonymous force, could lead art to exploit the "natural forces that fill heaven and earth."

Bergson's contributions to Camera Work consist of an excerpt from Laughter (1900) and one from Creative Evolution (1911). Both passages reflect the French philosopher's well-known idealism. The quotation from Laughter answers the question "what is the object of art?" by saying that its purpose is "to brush aside . . . everything that veils reality from us." The second selection, from Creative Evolution, sets up a dichotomy between the "modes" of instinct and intelligence. Instinct finds its subject in "life" and activates itself as art; intelligence looks to inert matter and results in science. Instinct, when "disinterested, self-conscious, [and] capable of reflecting on its object and of enlarging it indefinitely," becomes intuition, which in turn leads to the "very inwardness of life." All of these ideas accord with Stieglitz's philosophy, especially with his belief, mentioned earlier as evidence of his anti-realism, that "photography brings what is not visible to the surface."

Santayana's writings never appeared in Camera Work, but elsewhere Stieglitz referred to browsing the essays

in Character and Opinion in the United States and said that he found them "worth reading." According to Herbert J. Seligmann, Stieglitz delighted in the works of Santayana and relished his "masterly and flowing style."[54] Given this appreciation, Stieglitz must have come into contact, at one time or another, with The Sense of Beauty, and assuredly he would have agreed with Santayana's conclusion regarding experience and aesthetics. Beauty, says the philosopher, is a "species of value" that springs from the "immediate and inexplicable reaction to the vital impulse [cf. Bergson's élan vital] and from the irrational part of our nature."[55]

Like Santayana, Bergson, and Maeterlinck, Stieglitz believed that the creative person was "driven by an urge coming from beyond its own knowing, its own control."[56] Paul Rosenfeld, always a deep diver, put it this way: "At the base of [Stieglitz's] entire photographic work there stands a certain force of things in themselves, a certain impulse of ideal aspiration and spiritual growth."[57] That impulse imaged itself, for example, in Stieglitz's Poplar Trees, Lake George, a picture involving, again in Rosenfeld's words, "shapes that appear both to reach upward to some perfection and simultaneously plunge their roots downward into the bowels of things."[58] Stieglitz's abiding and, over the years, strengthening sense of the élan vital increased the outer-directed component of his art and limited the degree to which he abstracted subject matter from his photographs.

The particular essays in Character and Opinion in the United States that Stieglitz found worth reading were Santayana's commentaries on Josiah Royce and William James, and those on materialism and idealism. That selection itself reflects the deep-seated dialectic in Stieglitz's life, for Royce's absolute idealism and James's empiricism represent the two opposing halves of Stieglitz's being. The fact that this dialectic existed in Stieglitz so fruitfully and for so long a time implies some sort of resolution or synthesis, and indeed his theory of the equivalent is itself a kind of synthesis, but alone and unaided it leaves a few ambiguities. Consider, for example, his parable of the perfect negative, as told to Dorothy Norman in the last years of his life. The parable is short enough to be quoted in its entirety:

I will be sitting holding the plate
of a photograph I have just taken.
It will be the picture I have always
known that someday I would be able
to make. It will be the perfect neg-
ative, embodying all that I have ever
wished to say. I will have just
developed it, just have looked at it,
just have seen that it is precisely
what I wanted to achieve. The room
in which I happen to be sitting will
be empty, quiet. The walls will be
bare--clean. I will sit looking at
the picture. It will slip from my
hands. It will break as it falls to
the ground. I will be dead. The
people will come. No one will see
the picture. No one will ever know
what it was. That, for me, is my
definition of perfection.[59]

The photographer then explained that the meaning
of this parable concerned the "relationship of the per-
fect thing to the people." He concluded, "The perfect
thing in life has no chance." Such a pessimistic
deduction he no doubt felt was supported by the many
instances in which the public had failed to "see" what
he had actually achieved. How much blinder they would
be to perfection, he seemed to imply. Nevertheless,
is this not a curious allegory to come from the lips of
someone who spent much of his life editing photographic
journals and directing art galleries? Curious, yes,
until one applies Croce's aesthetics and discovers why
Stieglitz could rightly insist that he was no defeatist.

It is nearly impossible today to fix the exact
extent to which Stieglitz actually read Croce, but his
general awareness of the Italian aesthetician cannot be
doubted. A leader in American art could hardly have
avoided knowing the main theories of the man identified
by historians as "unquestionably the most influential
aesthetician" of the time. Georgia O'Keeffe recalled
for the present writer that, although Stieglitz had
unpredictable reading habits, discussions of Croce were
very much in the air after his Aesthetics as Science of
Expression and General Linguistics was released in Amer-
ica. And Dorothy Norman clearly remembers sharing her
copy of that treatise with Stieglitz.[60] Also he might
have seen Croce's essays in the Dial, a magazine closely

affiliated with the Stieglitz circle. At any rate, Stieglitz's readings in Bergson, Maeterlinck, and Santayana would have sufficed to acquaint him with many of Croce's ideas, for the Italian had infiltrated them all.

Croce begins his approach to aesthetics by dividing conscious life into two modes: the theoretical and the practical. The theoretical mode, he goes on, is either intuitive or intellectual [cf. Bergson's dichotomy]. Intuition gives the content of knowledge; intellect arranges the data. Intuition is the preeminent faculty of the artist; intellect belongs to the scientist and the philosopher.

Having separated art from "practical" activities and grounded it exclusively on intuition, Croce proceeds to define the fundamental aesthetic event as that moment of "lyrical intuition" when, in the artist's consciousness, his emotions fuse with a set of images. Since they exist in the realm of the "theoretical," the images are free of any ties to reality. The lyrical part of Croce's definition stresses the basic subjectivity, or egoism, of the artist's motive.

Any concretization of that intuitive moment-- painting the picture, playing or scoring the music, writing or even saying the poem--Croce defines as communication, the intuitive act itself being expression. Because such expression is common to all of the arts, they are, says Croce, essentially one. All works of art, according to this analysis, spring from the conscious synthesis of emotion and images.

Now let us see how these principles apply to the parable quoted earlier. Stieglitz's conscious recognition of the perfect negative in his hand corresponds to Croce's crucial moment of expression, a moment involving the fusion of the images on the negative with Stieglitz's total emotional experience. Any objectification of this moment--printing the negative, for example, or even showing the plate to someone else-- would constitute communication, which Croce specifies is a practical and therefore not an aesthetic activity. The essential artist is quite fulfilled by the moment of "lyrical or pure intuition." Thus in the parable Stieglitz is content to see the negative plate break and then to die without communicating his vision to "the people."

The perfection parable dramatizes Stieglitz's aesthetic idealism and further explains his seemingly spiteful reluctance to disseminate his own work--although, as indicated elsewhere, his insistence on quality was another reason why he scorned popularization. But if Croce is right, then Stieglitz as an artist was fulfilled by the aesthetic, or theoretical, component of his career. Public appreciation and understanding were not essential to him, being "practical" matters of communication, not expression.

Now let us turn to an actual instance of Stieglitz's equivalent and see if the Crocean analogy holds. The photograph that Stieglitz himself commented on at length and considered his greatest achievement is The Steerage. It "happened," he said, this way. In 1907 he sailed for Europe with his wife and child aboard one of the fashionable liners of the day. As the ship made its way across the Atlantic, Stieglitz became increasingly oppressed by the nouveau-riche atmosphere of the first class section. Repelled by all around him, the photographer walked out on deck and looked down into the steerage area. The scene transfixed him. Here is how he described his reaction: "I stood spellbound for a while, looking and looking. Could I photograph what I felt, looking and looking and still looking. I saw shapes related to each other. I saw a picture of shapes."61

According to Croce's aesthetics, that instant was the moment of lyrical intuition. Stieglitz's emotions and a set of images had synthesized in his consciousness. The shipboard situation was not unlike that which produced Winter, Fifth Avenue and The Terminal, but with one crucial difference. In 1893 the photographer's feelings had been purely personal, a matter of his own loneliness and isolation, but unrelated to other people. On the deck of the ship, however, he heard, in effect, Wordsworth's "still, sad music of humanity"; like Whitman he uttered the word "En-Masse."

Stieglitz explained that what possessed him on the ship was a "new vision," one compounded of "people, the feeling of ship and ocean and sky and the feeling of release from the mob called the rich." Indeed, in its expansiveness and universality, that new vision was an advance in his aesthetic evolution, a higher stage of development than the egocentrism of his earlier masterpieces.

Stieglitz's new vision touched the limits of the theoretical mode of consciousness, in Croce's terms; but every artist has, to some degree, a practical side. Also, the empirical motive was exceptionally strong in Stieglitz, urging him always to test his intuitions. And so on the ship he raced for his camera, made an exposure holding his breath, and, as soon as he could find a darkroom ashore, developed the plate. "The negative was perfect in every particular," he exulted.

Here I would depart from Croce to the extent of saying that for Stieglitz this was the crucial moment of expression, in that the synthesis of emotion and shapes was not validated until he saw the negative. Croce would call the making of the negative "communication," even though no one but the photographer had seen it at that point.

Stieglitz's sense of fulfillment when he beheld the negative of The Steerage corresponds to the moment in the perfection parable immediately preceding the breakage of the plate and the photographer's death. But in real life the plate did not break, and Stieglitz had almost forty more years to live.

He made a print of The Steerage and showed it tentatively to his associate Joseph Keiley, an accomplished photographer in his own right. Keiley responded, "But you have two pictures there, Stieglitz, an upper one and a lower one." The picture's creator, however, had absolute faith in his original intuition; he ignored the criticism and explained, "I realized he didn't see the picture I had made." In other words, Keiley, for all his expertise, here lacked the crucial ability to re-create the intuitive synthesis of emotion and image.

Stieglitz realized that the first test of The Steerage failed not because of the work itself but because the "instrument of measurement" (in this case, Keiley) was faulty. It happened again when the special edition of the magazine 291 featuring The Steerage went begging.[62] Stieglitz scrapped the unsold copies. As an artist he had contributed all that could be required of him by creating the photograph. All the rest, to both Stieglitz and Croce, was mere communication. Also, the empirical method prevented Stieglitz from affecting the reactions of his "instruments," here the public. In this spirit he said:

> No attempt was made to solicit sub-
> scribers or to sell the magazine
> [291]. What interested me most was
> to see what the American people would
> do if left to themselves. That has
> been an underlying principle in
> everything I've touched all these
> years.

Stieglitz's literary associates were keenly aware
that his photography, by enacting the Crocean synthesis
of emotion and image, also proved the fundamental unity
of the arts. Hart Crane was the most responsive to
what he called Stieglitz's "photographic synthesis of
life."[63] In The Bridge he himself was consciously
undertaking a "cultural synthesis of values in terms of
our America."[64] Thus he felt justified in exclaiming
to Stieglitz at the outset of their relationship, "I
am your brother always."[65] To Crane as to Stieglitz,
all artists were a family, related by their common
faculty of lyrical intuition.

But the ultimate comment on the Stieglitzian syn-
thesis was offered by the perspicacious Paul Rosenfeld:

> In all cases the subject matter and
> the artist were one: what confronted
> one was simultaneously the momentary
> appearance of the object registered
> with the delicacy and precision of
> the scientific apparatus, and a sys-
> tem of relationships of black and
> white representative of the system
> of values created in the artist by
> his experience, and expressive of
> the unseen forces at work in things.
> . . . [Stieglitz's photography]
> forces us to conceive a relative
> equivalence between what exists with-
> out the photographer in the form of
> the object and what exists within
> him as a system of values. What is
> photographed and what photographs
> appear to be almost identical.[66]

The most important literary consequence of Stieg-
litz's life and his aesthetics, in my opinion, was his
challenge to others to find gratification in the artis-
tic act itself rather than to hunger for conventional

success. To those around him he gave the fortitude to
endure public neglect and even abuse, art being in his
eyes its own reward. His letters to writers reiterate
the message that artists should do their best work and
ignore the carpers who cannot "see"--who cannot, that
is, partake of the lyrical intuition underlying the
work of art. And I am sure that his letters reflect
only a fraction of what he conveyed in his conversa-
tions, for talking was his weapon of preference in
dealing with the world.

Much of his talk has vanished now--only a few of
the faithful wrote it down--but the following tribute
to 291, again by Rosenfeld, dramatizes the call that
Stieglitz presented to the national consciousness.
Rosenfeld realized that Stieglitz inspired writers like
himself to face the ordeal of the American artist.
Thus at 291, he wrote, "you heard again, clearly, per-
suasively, the summons seated in the center of you,
saw presented to you the steep, the difficult, the
daring pathway up which you had to go."67

At the end of that pathway was, and is, a bright
new spirit in life, literature, and the arts. Such is
the abiding legacy of the inner eye of Alfred Stieglitz:
the personal challenge to each of us to do his best
always, a summons that daily becomes more imperative.

NOTES

CHAPTER 7

[1] A convenient synopsis of Stieglitz's periods is included in Doris Bry, Alfred Stieglitz: Photographer (Boston: Museum of Fine Arts, 1965), pp. 9-20.

[2] Alfred Stieglitz, "Pictorial Photography," Scribner's, Nov. 1899, p. [528].

[3] Alfred Stieglitz, "Modern Pictorial Photography," Century, Oct. 1902, p. 825.

[4] Ibid., p. 822.

[5] Norman, AS: Intro., p. 36; Stieglitz's italics.

[6] Ibid., p. [37].

[7] For Stieglitz's explication of Winter, Fifth Avenue and The Terminal, see Dorothy Norman, "From the Writings and Conversations of Alfred Stieglitz," Twice a Year, no. 1 (Fall-Winter 1938), pp. 96-98; Alfred Stieglitz, "Ten Stories," Twice a Year, no. 5-6 (Fall-Winter, Spring-Summer 1940-41), p. 142; and Norman, AS: Intro., pp. 8-11.

[8] Sheldon Cheney, A Primer of Modern Art (New York: Boni & Liveright, 1924), p. 232.

[9] Dorothy Norman, "From the Writings and Conversations of Alfred Stieglitz," Twice a Year, no. 1 (Fall-Winter 1938), pp. 77-110.

[10] Cheney, p. 229.

[11] Quoted in Bry, p. 20.

[12] Alfred Stieglitz, "Ten Stories," Twice a Year, nos. 5-6 (Fall-Winter, Spring-Summer 1940-41), p. 142. "Car Horses" is a reference to The Terminal.

13 Joseph Warren Beach, The Twentieth Century Novel: Studies in Technique (New York: Appleton-Century-Crofts, 1932), p. 485.

14 Hart Crane to AS, April 15, 1923; in Letters of HC, p. 132.

15 In his Essai sur l'Imagination créatice (Paris, 1900), Théodule Ribot distinguishes between two types of imagination: the "plastic" imagination is characterized by sharp visualization incited by observation of the outside world [cf. impressionism]; the "diffluent" imagination projects emotions and feeling through rhythms and images unified by the artist's mood or frame of mind [cf. expressionism].

16 Harlan Hatcher calls Rahab a "highly impressionistic novel" but concedes that Frank "was concerned with the feelings behind action, not [with] mere objective activity." This admission actually pinpoints Frank's expressionism, as does Hatcher's criticism that his characters are "insubstantial shadows of an excited mind" (Creating the Modern American Novel [New York: Farrar and Rinehart, 1935], pp. 174-75).

17 Quoted in Norman Holmes Pearson, "Anderson and the New Puritanism," Newberry Library Bulletin, 2nd series, no. 2 (Dec. 1948), p. 57.

18 Sherwood Anderson to AS, Aug. 3, 1924; in Letters of SA, p. 129.

19 Sherwood Anderson to John Anderson [?April 1927]; in Letters of SA, p. 166.

20 Gorham Munson, Destinations: A Canvas of American Literature Since 1900 (1928; rpt. New York: Folcroft, 1969), p. 174.

21 Hart Crane to Sherwood Anderson, July 4, [1923]; in Letters of HC, p. 139.

22 Jean Toomer, "The Hill," in Frank, America & AS, p. 298.

23 Dreiser, The "Genius," p. 114.

24 Munson, Destinations, p. 106.

25 Stein, "How Writing Is Written," passim.

26 Paul Rosenfeld to AS, July 20, 1928.

27 Paul Rosenfeld to AS, Aug. 3, 1928.

28 Paul Rosenfeld, "Stieglitz," Dial, 70 (1921), 407. Rosenfeld did not examine The Steerage closely enough; the only person in the picture who might seem to be picking his nose is actually twirling his moustache.

29 Paul Rosenfeld, "The Novels of Waldo Frank," Dial, 70 (1921), 105.

30 Anderson, A Story Teller's Story, p. 360.

31 In his "Thoughts on Art" (Dial, 2 [1841], 367-78), Emerson blatantly contradicts the organic principles affirmed in "The Problem"; but perhaps this is merely another defiance of the "hobgoblin of a foolish consistency."

32 Harold Rugg, "The Artist and the Great Transition," in Frank, America & AS, p. 196.

33 Quoted in Robert Doty, Photo-Secession (Rochester, N.Y.: George Eastman House, 1960), p. 19.

34 Quoted in Norman, AS: Intro., pp. 6, 25. Note the echo of Bergson's élan vital, G. B. Shaw's "Life-Force," and D. H. Lawrence's "Life-Urge."

35 AS to Hart Crane, Oct. 9, 1923; Columbia Univ. Library.

36 Hart Crane to AS, Dec. 27, [1925].

141

[37] Hart Crane to Waldo Frank, June 20, [1926]; in Letters of HC, p. 261.

[38] AS to Waldo Frank, Oct. 30, 1919.

[39] Waldo Frank to AS, Dec. 5, [1933].

[40] Rosenfeld's letter has vanished, but Stieglitz quoted and underscored the word flow in his reply of Nov. 17, 1923.

[41] AS to Sherwood Anderson, Oct. 11, 1923.

[42] Sherwood Anderson to Charles Bockler, [?1930]; in Letters of SA, p. 202.

[43] AS to Waldo Frank, Sept. 4, 1930.

[44] Anderson to Rosenfeld, July 4, 1923. The photographs mentioned by Anderson ("the barks of a tree, young birches I think" and "a tiny white house at the foot of a hill") are probably those reproduced as plates 34 and 38 respectively in Doris Bry, Alfred Stieglitz: Photographer.

[45] In Letters of SA, p. 283.

[46] Waldo Frank, "Sherwood Anderson: A Personal Note," Newberry Library Bulletin, 2nd series, no. 2 (Dec. 1948), p. 39.

[47] Hart Crane to Gorham Munson, March 2, 1923; in Letters of HC, p. 129.

[48] Alfred Stieglitz, "Regarding the Modern French Masters Exhibition," Brooklyn Museum Quarterly, 8, no. 3 (July 1921), 112.

[49] Quoted in Frank, America & AS, p. 118.

[50] Quoted in Norman, AS: Intro., p. [26].

[51] Paul Rosenfeld, "The Photography of Stieglitz," *Nation*, 134 (1932), 350; italics added.

[52] Ibid.

[53] For a detailed examination of the Bergson-Maeterlinck influence on Stieglitz, see Joseph Shiffman, "The Alienation of the Artist: Alfred Stieglitz," *American Quarterly*, 3 (1951), 244-58.

[54] Herbert J. Seligmann, "Burning Focus," *Infinity*, Jan. 1968, p. 32.

[55] George Santayana, *The Sense of Beauty*, rev. ed. (New York: Scribner's, 1904), p. 17.

[56] Dorothy Norman, "From the Writings and Conversations of Alfred Stieglitz," *Twice a Year*, no. 1 (Fall-Winter 1938), p. 77; reprinted in Norman, *AS: Intro.*, p. 25.

[57] Rosenfeld, "The Photography of Stieglitz," p. 351.

[58] Ibid.

[59] Quoted in Norman, *AS: Intro.*, pp. 64-65.

[60] Statements about Benedetto Croce in this study are based on his *Aesthetic as Science of Expression and General Linguistic*, trans. Douglas Ainslie, 2nd ed. (London: Macmillan, 1922); and on his signed article "Aesthetics" in the *Encyclopaedia Britannica*, 1938 ed. The former work was originally published in Italy in 1902 as *Estetica come scienza dell' expressione e linguistica generale*. It was reviewed anonymously in the *Nation* of September 25, 1902 (pp. 252-53).

[61] For Stieglitz's remarks about the making of *The Steerage* and the aftermath, see his "Four Happenings," in *Twice a Year*, nos. 8-9 (Spring-Summer, Fall-Winter 1942), pp. 127-36; and Seligmann, *AS Talking*, pp. 79-80. The quotations in this study were taken from the *Twice a Year* account.

[62] A single copy of *The Steerage* recently sold for more than $5,000.

[63] Hart Crane to AS, July 4, [1923]; in *Letters of HC*, p. 139.

[64] Hart Crane to Otto Kahn, Dec. 3, 1925; in *Letters of HC*, p. 223.

[65] HC to AS, Aug. 11, 1923; in *Letters of HC*; Crane's italics.

[66] Rosenfeld, "The Photography of Stieglitz," pp. 350-51.

[67] Rosenfeld, *Port of New York*, p. 259.

BIBLIOGRAPHY

Allan, Sidney [Sadakichi Hartmann]. "Repetition, with Slight Variation." Camera Work, no. 1 (Jan. 1903), pp. 30-34.

Anderson, Sherwood. "Alfred Stieglitz." New Republic, Oct. 25, 1922, pp. 215-17.

----------. A Story Teller's Story. New York: B. W. Huebsch, 1924.

----------. Dark Laughter. New York: Liveright, 1925.

----------. Letters of Sherwood Anderson. Ed. Howard Mumford Jones and Walter B. Rideout. Boston: Little, Brown, 1953.

----------. Poor White. New York: B. W. Huebsch, 1920.

----------. "Seven Alive." Dial, 78 (1925), 435-36.

----------. Sherwood Anderson's Memoirs. New York: Harcourt, Brace & World, 1942.

----------. Sherwood Anderson's Notebook. New York: Boni & Liveright, 1926.

----------. The Sherwood Anderson Reader. Ed. Paul Rosenfeld. Boston: Houghton Mifflin, 1947.

----------. Windy McPherson's Son. 2nd rev. ed. New York: B. W. Huebsch, 1922.

Beach, Joseph Warren. The Twentieth Century Novel: Studies in Technique. New York: Appleton-Century-Crofts, 1932.

Bergson, Henri. Creative Evolution. Trans. Arthur Mitchell. New York: Holt, 1911.

----------. Laughter: An Essay on the Meaning of the Comic. Trans. Cloudesley Brereton and Fred Rothwell. New York: Macmillan, 1911.

Bittner, William. The Novels of Waldo Frank. Philadelphia: Univ. of Pennsylvania Press, 1958.

Brinnin, John. The Third Rose: Gertrude Stein and Her World. Boston: Little, Brown, 1959.

Brooks, Van Wyck. _An Autobiography_. New York: Dutton, 1965.

----------. _The Confident Years, 1885-1915_. New York: Dutton, 1952.

Bry, Doris. _Alfred Stieglitz: Photographer_. Boston: Museum of Fine Arts, 1965.

Carter, Paul J. _Waldo Frank_. New York: Twayne, 1967.

Cheney, Sheldon. _A Primer of Modern Art_. New York: Boni & Liveright, 1924.

Crane, Hart. _The Bridge_. New York: Liveright, 1930.

----------. _The Letters of Hart Crane, 1916-1932_. Ed. Brom Weber. Berkeley and Los Angeles: Univ. of California Press, 1965.

----------. _White Buildings_. New York: Boni & Liveright, 1926.

Croce, Benedetto. _Aesthetic as Science of Expression and General Linguistic_. Trans. Douglas Ainslie. 2nd ed. London: Macmillan, 1922.

----------. "Aesthetics." _Encyclopaedia Britannica_, 1938 ed.

Dahlberg, Edward. _The Confessions of Edward Dahlberg_. New York: George Braziller, 1971.

Dijkstra, Bram. _The Hieroglyphics of a New Speech: Cubism, Stieglitz, and the Early Poetry of William Carlos Williams_. Princeton: Princeton Univ. Press, 1969.

Doty, Robert. _Photo-Secession: Photography as a Fine Art_. Rochester, N.Y.: George Eastman House, 1960.

Dreiser, Theodore. "A Master of Photography." _Success_, June 10, 1899, p. 471.

----------. "A Remarkable Art." _Great Round World_, May 3, 1902, pp. 430-34; unsigned but generally attributed to Dreiser.

Dreiser, Theodore. "The Camera Club of New York."
 Ainslee's, 4 (1899), 324-35.

----------. "The Color of Today." *Harper's Weekly*,
 Dec. 14, 1901, pp. 1272-73.

----------. The "Genius." 1915; rpt. Cleveland and
 New York: Forum-World, 1963.

----------. "Life, Art and America." *Seven Arts*, 1
 (1917), 363-89.

Faulkner, William. "Sherwood Anderson: An Apprecia-
 tion." *Atlantic*, June 1953, pp. 27-29.

Frank, Waldo. "Alfred Stieglitz: The World's Greatest
 Photographer." *McCall's*, May 1927, pp. 24,
 107-08.

----------, et al., eds. *America and Alfred Stieglitz:
 A Collective Portrait*. Garden City, N.Y.:
 Doubleday, Doran, 1934.

----------. *City Block*. Darien, Conn.: Waldo Frank,
 1922.

----------. *In the American Jungle*. 1937; rpt. Free-
 port, N.Y.: Books for Libraries, 1968.

----------. *Our America*. New York: Boni & Liveright,
 1919.

----------. "Sherwood Anderson: A Personal Note."
 Newberry Library Bulletin, 2nd series, no. 2
 (Dec. 1948), pp. 39-43.

----------. *The Re-discovery of America: An Intro-
 duction to a Philosophy of Life*. New York:
 Scribner's, 1929.

----------. *Time Exposures by "Search-Light."* New
 York: Boni & Liveright, 1926.

Fuguet, Dallett. "Notes by the Way: The Man Behind the
 Camera." *Camera Work*, no. 2 (April 1903), p. 52.

Gallup, Donald. "The Weaving of a Pattern: Marsden Hartley and Gertrude Stein." <u>Magazine of Art</u>, 41 (Nov. 1948), 256-61.

Gilmer, Walker. <u>Horace Liveright: Publisher of the Twenties</u>. New York: David Lewis, 1970.

Gregory, Alyse. "Sherwood Anderson." <u>Dial</u>, 75 (1923), 242-46.

Haines, Robert E. (Ned). "Alfred Stieglitz and the New Order of Consciousness in American Literature." <u>Pacific Coast Philology</u>, 6 (April 1971), 26-34.

----------. "Anderson and Stieglitz: A Fellowship of Sayer and Seer." In <u>Sherwood Anderson Centennial Studies</u>. Ed. Hilbert H. Campbell and Charles E. Modlin. Troy, N.Y.: Whitston, 1976.

----------. "Image and Idea: The Literary Relationships of Alfred Stieglitz." Diss. Stanford Univ. 1967.

----------. "Turning Point: Sherwood Anderson Encounters Alfred Stieglitz." <u>Markham Review</u>, 6 (Fall 1976), 16-20.

Hapgood, Hutchins. <u>A Victorian in the Modern World</u>. 1939; rpt. Seattle: Univ. of Washington Press, 1972.

Hoffman, Michael J. "Gertrude Stein's 'Portraits.'" <u>Twentieth Century Literature</u>, 2 (Oct. 1965), 115-22.

----------. <u>The Development of Abstractionism in the Writings of Gertrude Stein</u>. Philadelphia: Univ. of Pennsylvania Press, 1965.

Homer, William Innes. <u>Alfred Stieglitz and the American Avant-Garde</u>. Boston: Little, Brown, 1977.

Hulme, T. E. <u>Speculations: Essays on Humanism and the Philosophy of Art</u>. London: K. Paul, Trench, Trubner, 1924.

Kazin, Alfred. "The Useful Critic." <u>Atlantic</u>, Dec. 1965, pp. 73-77, 79-80.

Knox, George. "Dos Passos and Painting." <u>Studies in Literature and Language</u>, 6 (1965), 22-38.

Kreymborg, Alfred. <u>Troubadour: An American Biography</u>. New York: Boni & Liveright, 1925.

Kunitz, Stanley J., Howard Haycraft, and W. C. Hadden, eds. <u>Authors Today and Yesterday: A Companion Volume to Living Authors</u>. New York: H. W. Wilson, 1933.

Kwiat, Joseph J. "Dreiser and the Graphic Artist." <u>American Quarterly</u>, 4 (1952), 331-38.

----------. "Dreiser's <u>The 'Genius'</u> and Everett Shinn, the 'Ash-can' Painter." <u>PMLA</u>, 67 (1952), 15-31.

Lehan, Richard. <u>Theodore Dreiser: His World and His Novels</u>. Carbondale: Southern Illinois Univ. Press, 1969.

Leonard, Neil. "Alfred Stieglitz and Realism." <u>Art Quarterly</u>, 29 (1966), 277-86.

Lessing, Gotthold. <u>Laocoön: An Essay upon the Limits of Painting and Poetry</u>. Trans. Ellen Frothingham. 1766; rpt. New York: Noonday, 1957.

Lyons, Nathan, ed. <u>Photographers on Photography</u>. Englewood Cliffs, N.J.: Prentice-Hall, 1966.

Matthiessen, F. O. <u>Theodore Dreiser</u>. New York: Sloane, 1951.

Mellquist, Jerome, and Lucie Wiese, eds. <u>Paul Rosenfeld: Voyager in the Arts</u>. New York: Creative Age, 1948.

Minuit, Peter [Paul Rosenfeld]. "291 Fifth Avenue." <u>Seven Arts</u>, 1 (1916), 61-65.

Moers, Ellen. <u>Two Dreisers</u>. New York: Viking, 1969.

Morris, Lawrence S. "Sherwood Anderson: Sick of Words." <u>New Republic</u>, Aug. 3, 1927, pp. 277-79.

Munson, Gorham. Destinations: A Canvas of American
 Literature Since 1900. New York: J. H. Sears,
 1928.

----------. "291: A Creative Source of the Twenties."
 Forum, 3 (Fall-Winter 1960), 4-9.

Norman, Dorothy. Alfred Stieglitz: An American Seer.
 New York: Random House, 1973.

----------. Alfred Stieglitz: Introduction to an
 American Seer. New York: Duell, Sloan and
 Pearce, 1960.

----------. "From the Writings and Conversations of
 Alfred Stieglitz." Twice a Year, no. 1 (Fall-
 Winter 1938), pp. 77-110.

----------. Stieglitz Memorial Portfolio, 1884-1946.
 New York: Twice a Year Press, 1947.

O'Keeffe, Georgia. Georgia O'Keeffe: A Portrait by
 Alfred Stieglitz. New York: Viking, 1979.

----------. "Stieglitz: His Pictures Collected Him."
 New York Times Magazine, Dec. 11, 1949, pp. 24,
 26, 28-30.

Pach, Walter. The Masters of Modern Art. New York:
 B. W. Huebsch, 1924.

Pearson, Norman Holmes. "Anderson and the New Puritan-
 ism." Newberry Library Bulletin, 2nd series,
 no. 2 (Dec. 1948), pp. 52-63.

Porter, Katherine Anne. "Gertrude Stein: A Self-
 Portrait." Harper's, Dec. 1947, pp. 519-28.

Rosenfeld, Paul. Men Seen: Twenty-four Modern Authors.
 New York: L. MacVeagh-The Dial Press, 1925.

----------. Port of New York: Essays on Fourteen
 Moderns. 1924; rpt. Urbana: Univ. of Illinois
 Press, 1966.

----------. "Stieglitz." Dial, 70 (1921), 397-409.

Rosenfeld, Paul. "The Novels of Waldo Frank." Dial, 70 (1921), 95-105.

----------. "The Photography of Stieglitz." Nation, 134 (1932), 350-51.

Santayana, George. The Sense of Beauty: Being the Outline of Aesthetic Theory. Rev. ed. New York: Scribner's, 1904.

----------. Character and Opinion in the United States. London: Constable, 1921.

Shiffman, Joseph. "The Alienation of the Artist: Alfred Stieglitz." American Quarterly, 3 (1951), 244-58.

Seligmann, Herbert J. Alfred Stieglitz Talking. New Haven: Yale Univ. Library, 1966.

----------. "Burning Focus," Part 1. Infinity, 16, no. 12 (Dec. 1967), 15, 17, 26-29.

----------. "Burning Focus," Part 2. Infinity, 17, no. 1 (Jan. 1968), 29, 31-34.

----------. D. H. Lawrence: An American Interpretation. New York: Thomas Seltzer, 1924.

----------. "Voyages, or Uphill All the Way: Synoptic Appraisal of a Life." (Unpublished biography, copyright 1968.)

Stearns, Harold E., ed. Civilization in the United States: An Enquiry by Thirty Americans. New York: Harcourt, Brace, 1922.

Stein, Gertrude. "From a Play by Gertrude Stein." Camera Work, no. 45 (Jan. 1914), pp. 17-18.

----------. "Henri Matisse." Camera Work, special number (Aug. 1912), pp. 23-25.

----------. "How Writing Is Written." Choate Literary Magazine, Feb. 1935, pp. 5-14; reprinted in various places including the Oxford Anthology of American Literature.

Stein, Gertrude. <u>Lectures in America</u>. New York: Random House, 1935.

----------. "Pablo Picasso." <u>Camera Work</u>, special number (Aug. 1912), pp. 29-30.

----------. "Portrait of Mabel Dodge at the Villa Curonia." <u>Camera Work</u>, special number (June 1913), pp. 3-5.

----------. <u>Tender Buttons: Objects, Food, Rooms</u>. New York: Claire Marie, 1914.

----------. <u>Three Lives</u>. New York: Grafton, 1909.

Stieglitz, Alfred. "Four Happenings." <u>Twice a Year</u>, nos. 8-9 (Spring-Summer, Fall-Winter 1942), pp. 105-36.

----------. Letter to Guido Bruno. <u>Bruno's Greenwich Village Magazine</u>, 1, no. 1 (1917), 8.

----------. "Modern Pictorial Photography." <u>Century</u>, 64 (Oct. 1902), 822-26.

----------. "Pictorial Photography." <u>Scribner's</u>, 26 (Nov. 1899), 528-37.

----------. <u>Picturesque Bits of New York and Other Studies</u>. New York: R. H. Russell, 1897.

----------. "Regarding the Modern French Masters Exhibition: A Letter." <u>Brooklyn Museum Quarterly</u>, 8, no. 3 (July 1921), 107-13.

----------. "Six Happenings (and a Conversation Recorded by Dorothy Norman)." <u>Twice a Year</u>, nos. 14-15 (Fall-Winter, Spring-Summer 1946-47), pp. 188-202.

----------. "Ten Stories." <u>Twice a Year</u>, nos. 5-6 (Fall-Winter, Spring-Summer 1940-41), pp. 135-161.

----------. "Thoroughly Unprepared" and other stories. <u>Twice a Year</u>, nos. 10-11 (Fall-Winter 1943), pp. 245-64.

Sutton, William Alfred. _Exit to Elsinore_. Muncie, Ind.: Ball State Univ. Press, 1967.

Swanberg, W. A. _Dreiser_. New York: Scribner's, 1965.

Unterecker, John. _Voyager: A Life of Hart Crane_. New York: Farrar, Straus and Giroux, 1969.

Weber, Brom. _Hart Crane: A Biographical and Critical Study_. New York: Bodley, 1948.

----------. _Sherwood Anderson_. Minneapolis: Univ. of Minnesota Press, 1964.

Williams, William Carlos. _The Autobiography of William Carlos Williams_. New York: Random House, 1951.

----------. "What of Alfred Stieglitz." Unpublished essay dated Oct. 16, 1946; in the Beinecke Rare Book and Manuscript Library.

Zigrosser, Carl. _The Artist in America: Twenty-four Close-ups of Contemporary Printmakers_. New York: Knopf, 1942.

ABOUT THE AUTHOR

Robert E. (Ned) Haines is a native Ohioan, educated at Ohio State and Stanford. A former Navy pilot, he was for several years an internationally published photographer and journalist, living and working at various times in Europe, Bermuda, and the United States. His interest in Alfred Stieglitz's literary relationships began with his doctoral dissertation at Stanford in 1967; and, in addition to the present volume, he has published three scholarly essays on the subject. His work in progress includes a photographic book on literary America, a project to which he and his wife have already devoted three years of full-time travel. Dr. Haines taught English and American literature for six years at the University of Alaska in Fairbanks. He is presently a professor of English at the Hillsborough Community College in Tampa, Florida.